Cumberland Island

FRANCESCO SALOMONI

Copyright © 2013 Francesco Salomoni

All rights reserved.

ISBN: 1493681915
ISBN-13: 9781493681914

In front of St. Marys, GA, is Cumberland Island. A short boat ride took us to the ruins of a once rich house of the gilded age, now home to rattlesnakes. We walked through the woods, passing old cars abandoned to rust, and reached the beach, where wild horses run free and rest peacefully. Shells and horseshoe crabs paved the beach. These images immortalize an Autumn day on Cumberland Island.

Photographs by

FRANCESCO SALOMONI

CUMBERLAND ISLAND

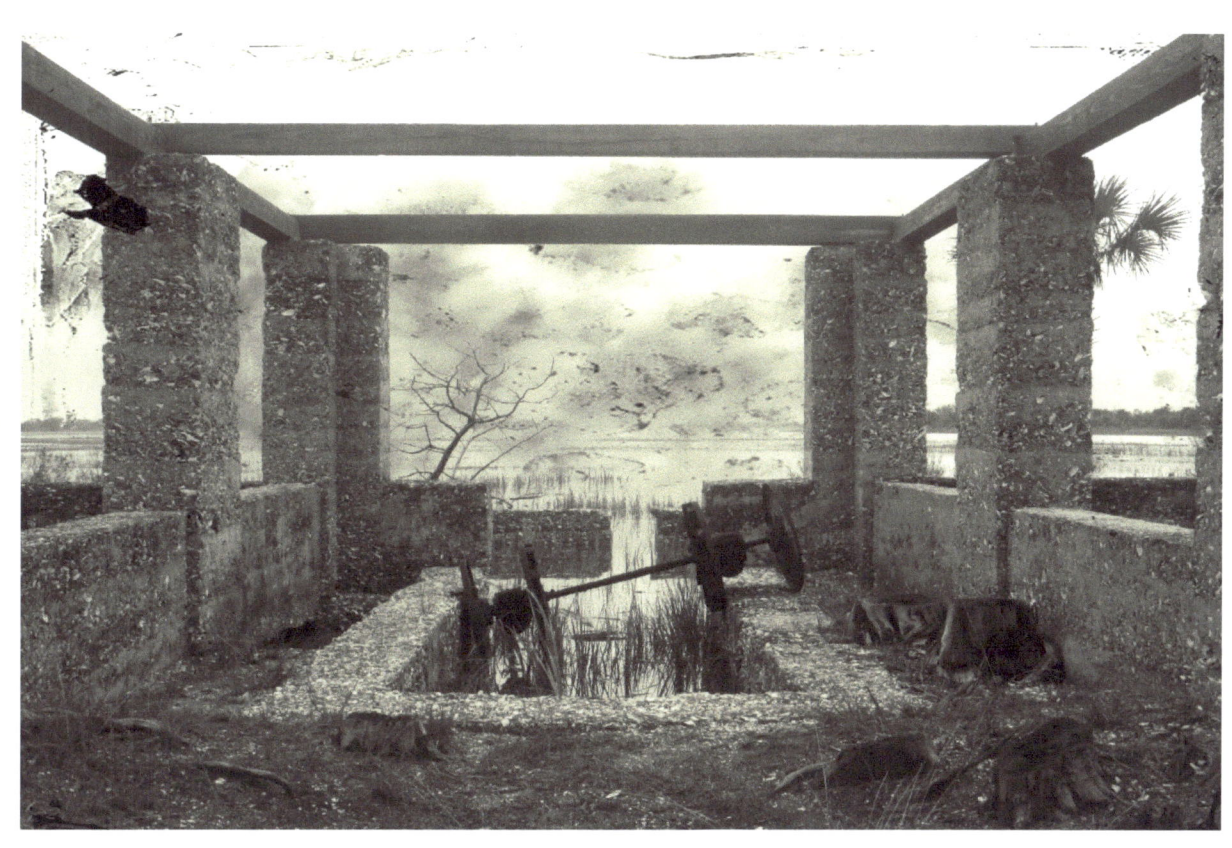

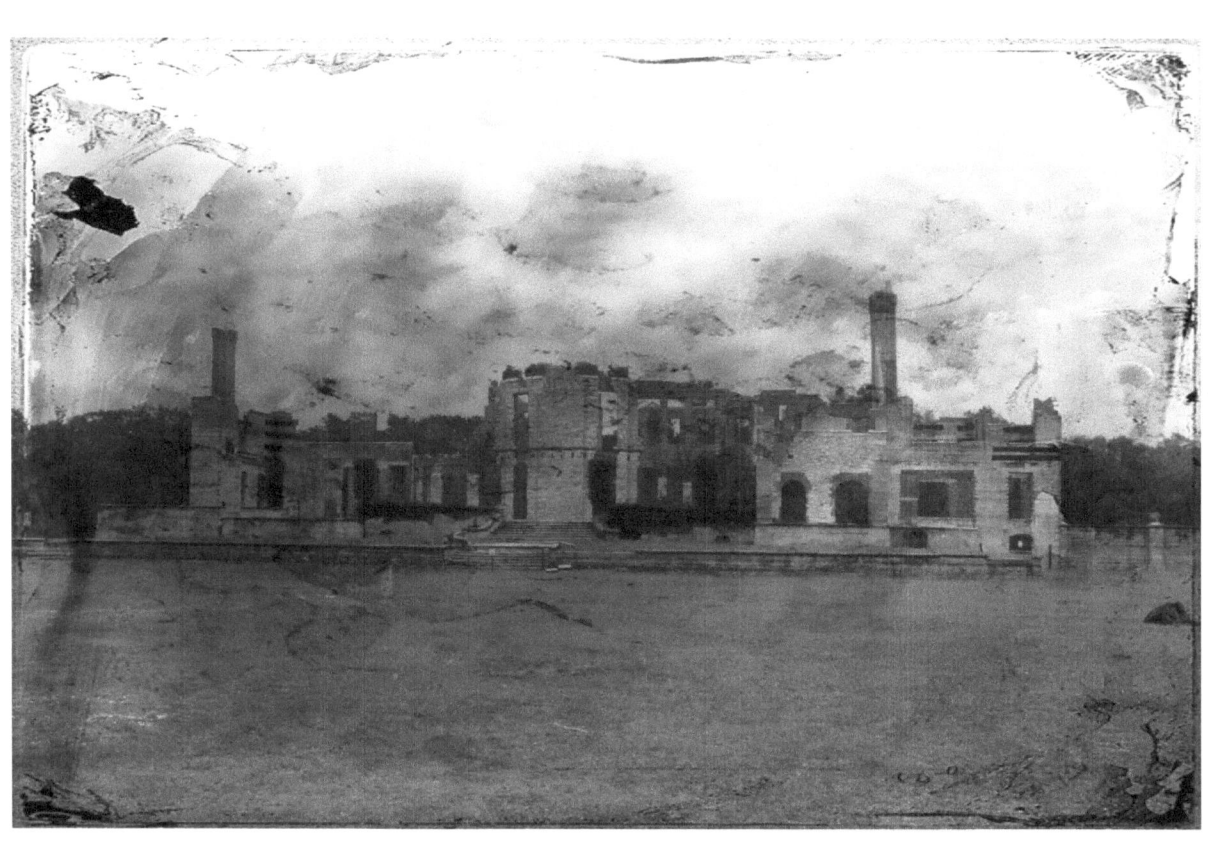

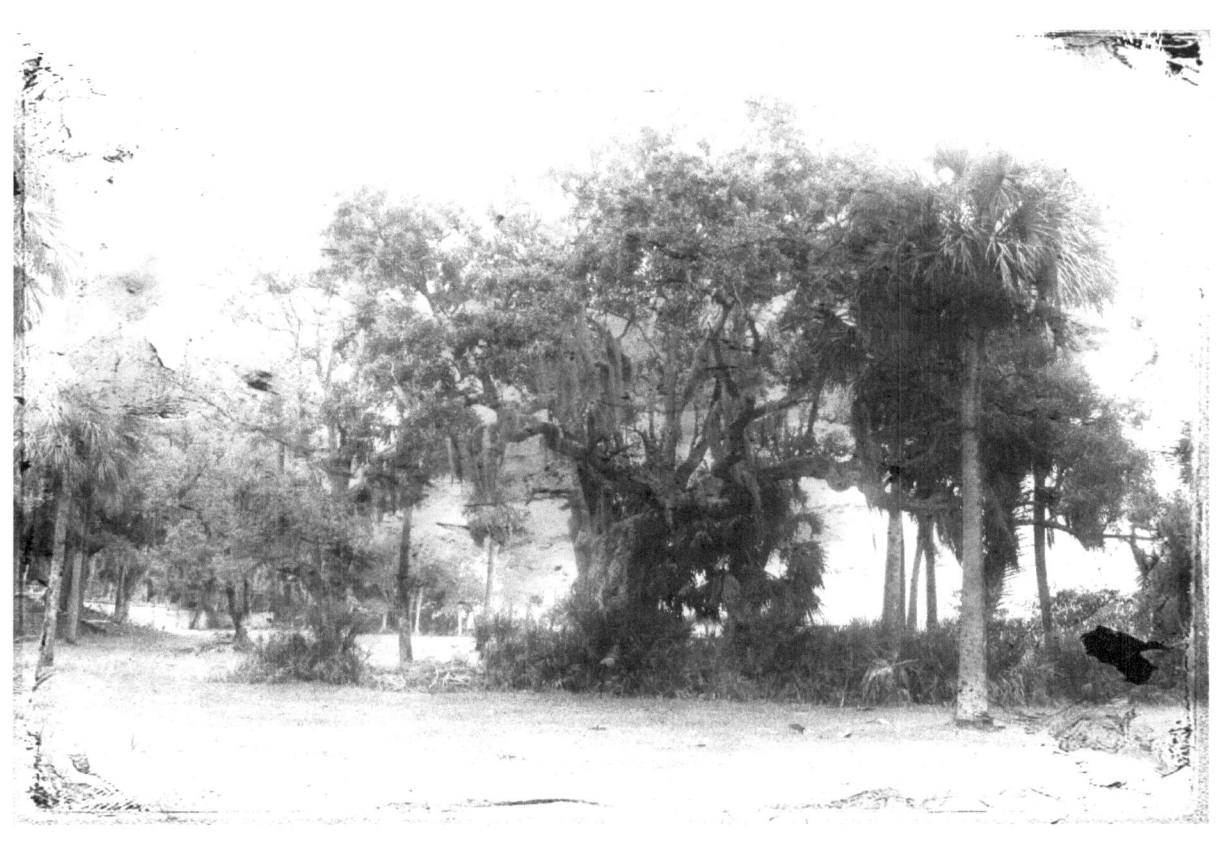

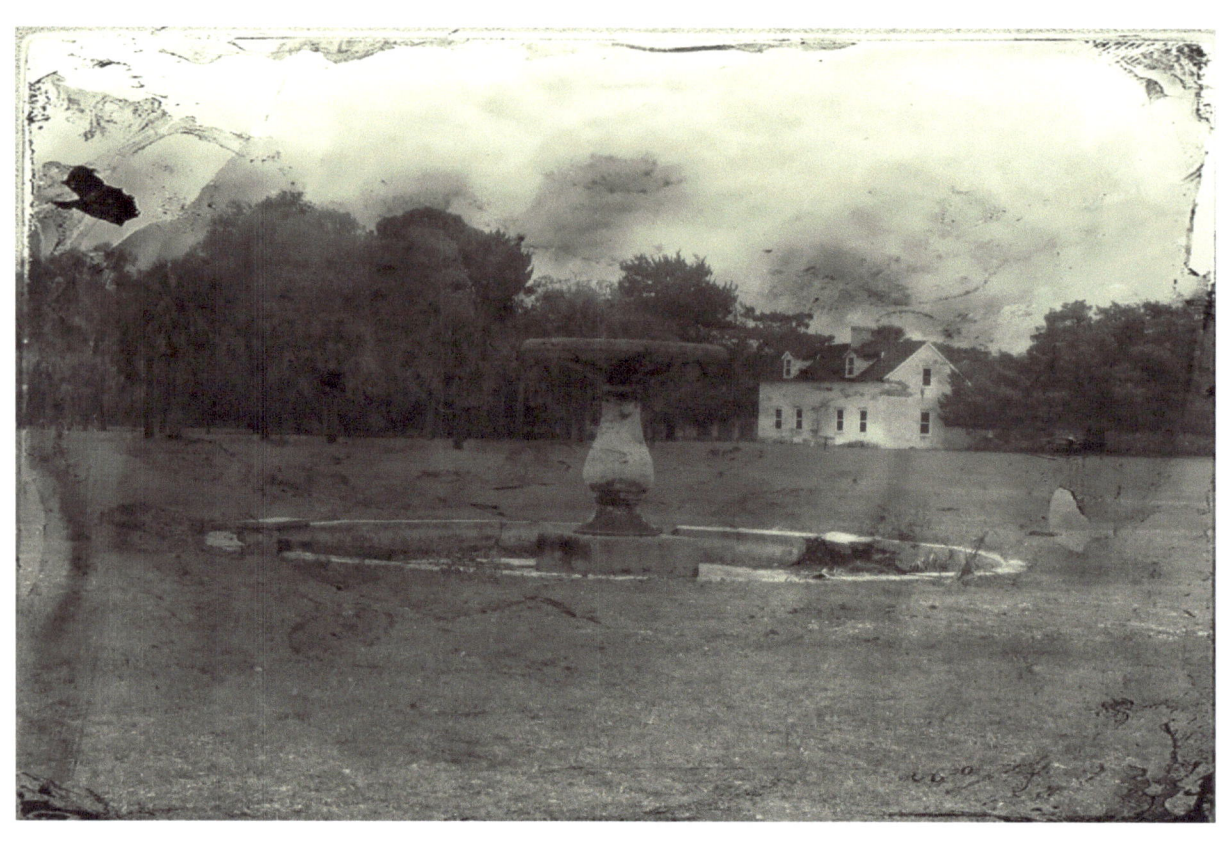

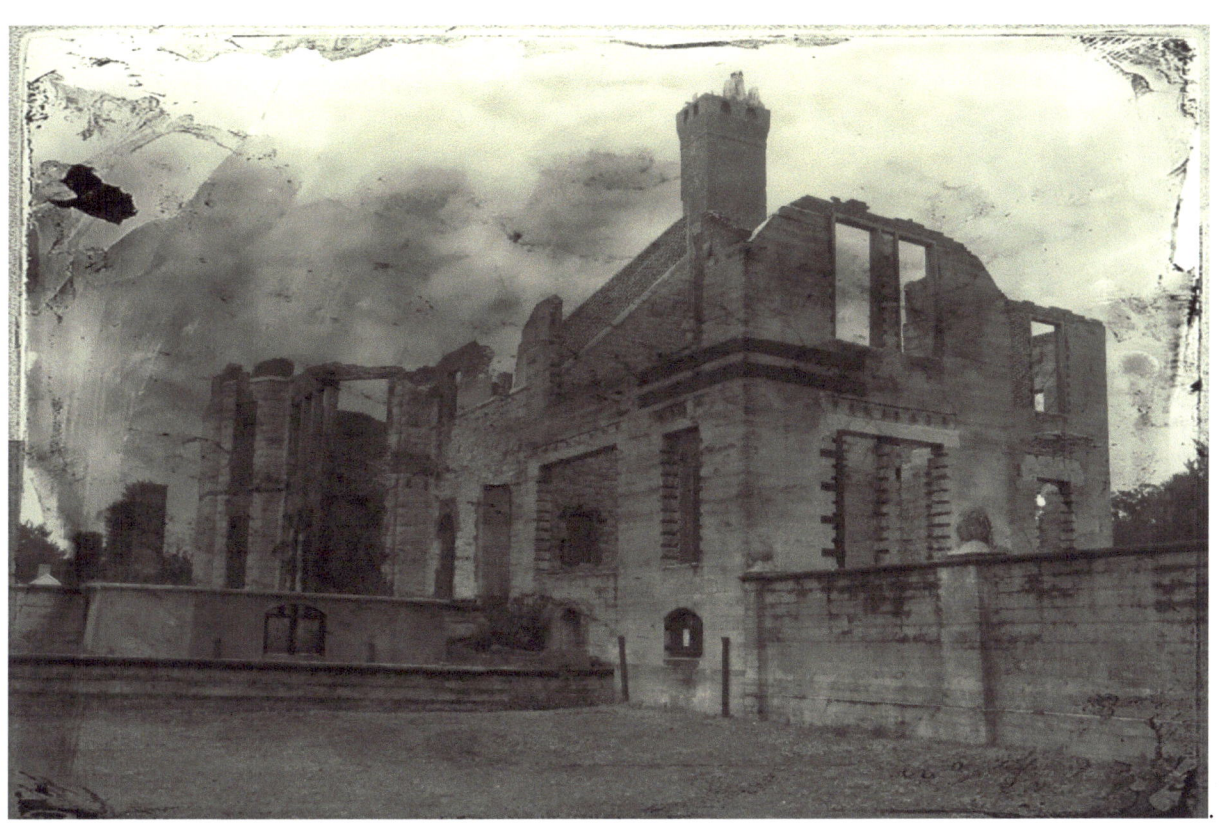

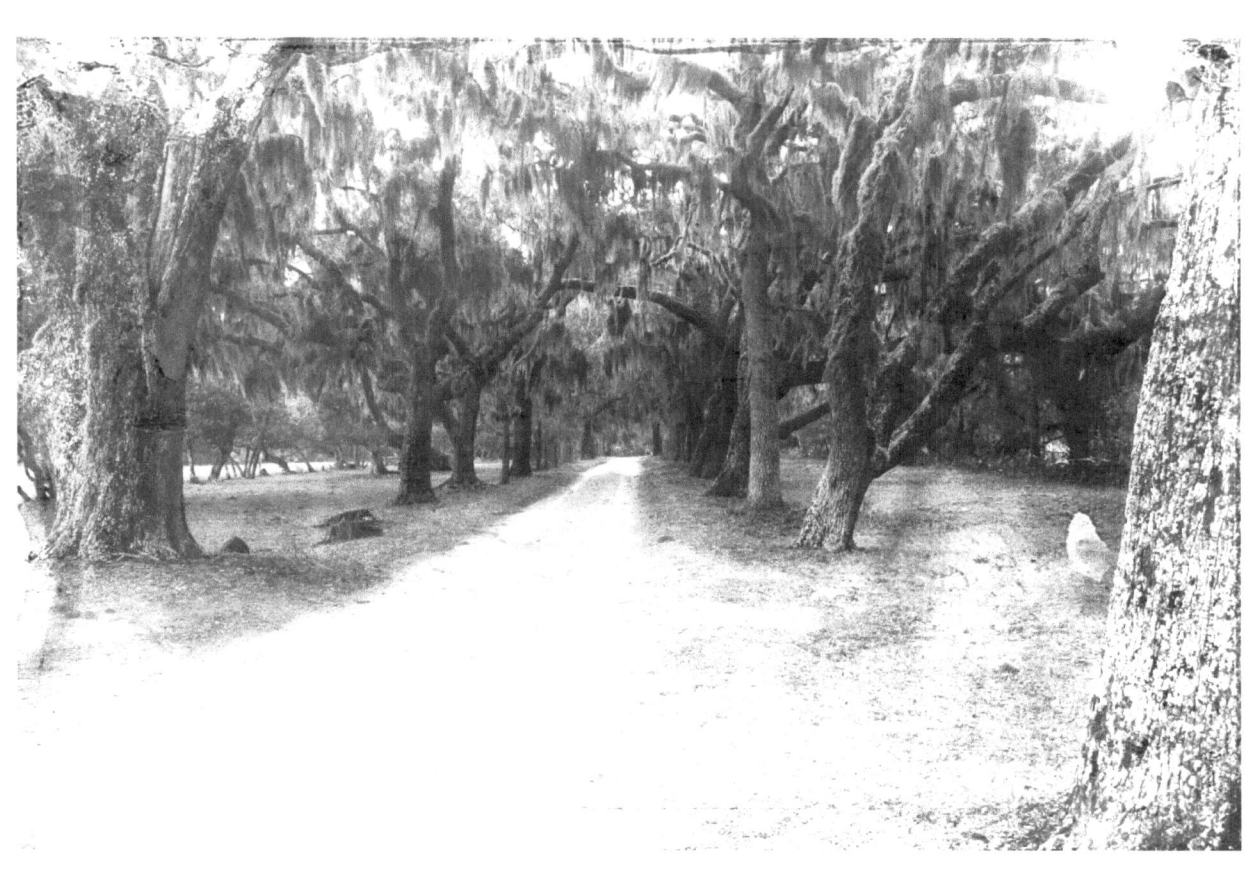

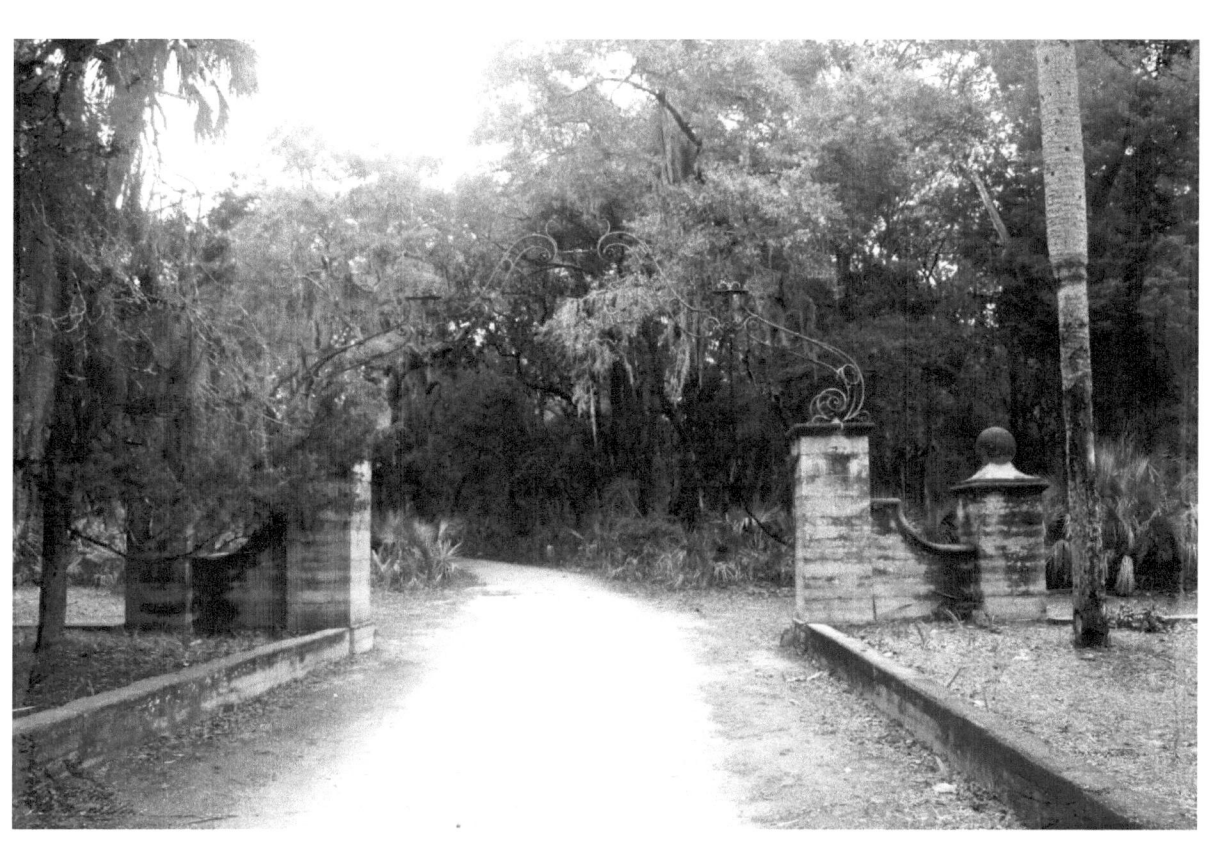

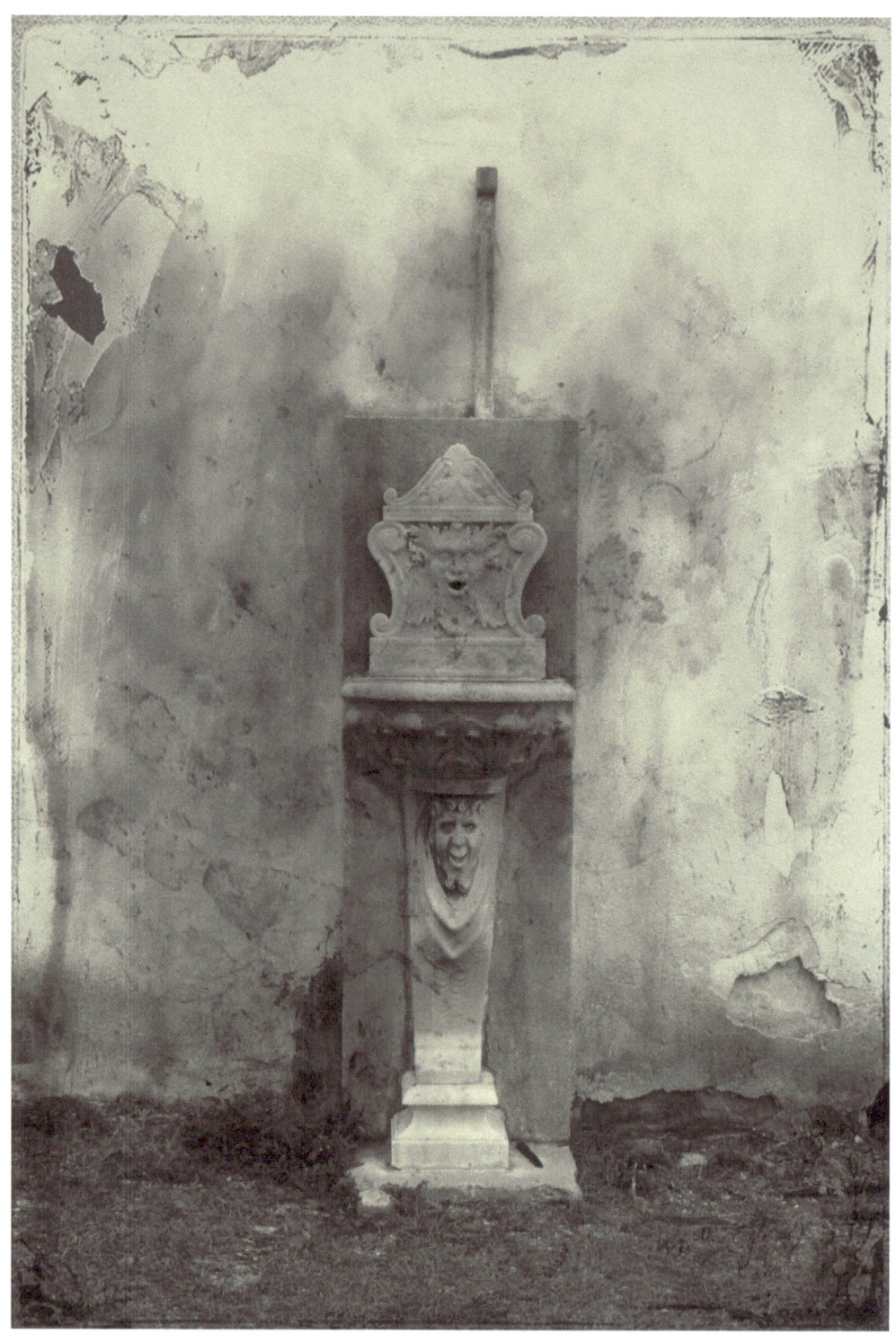

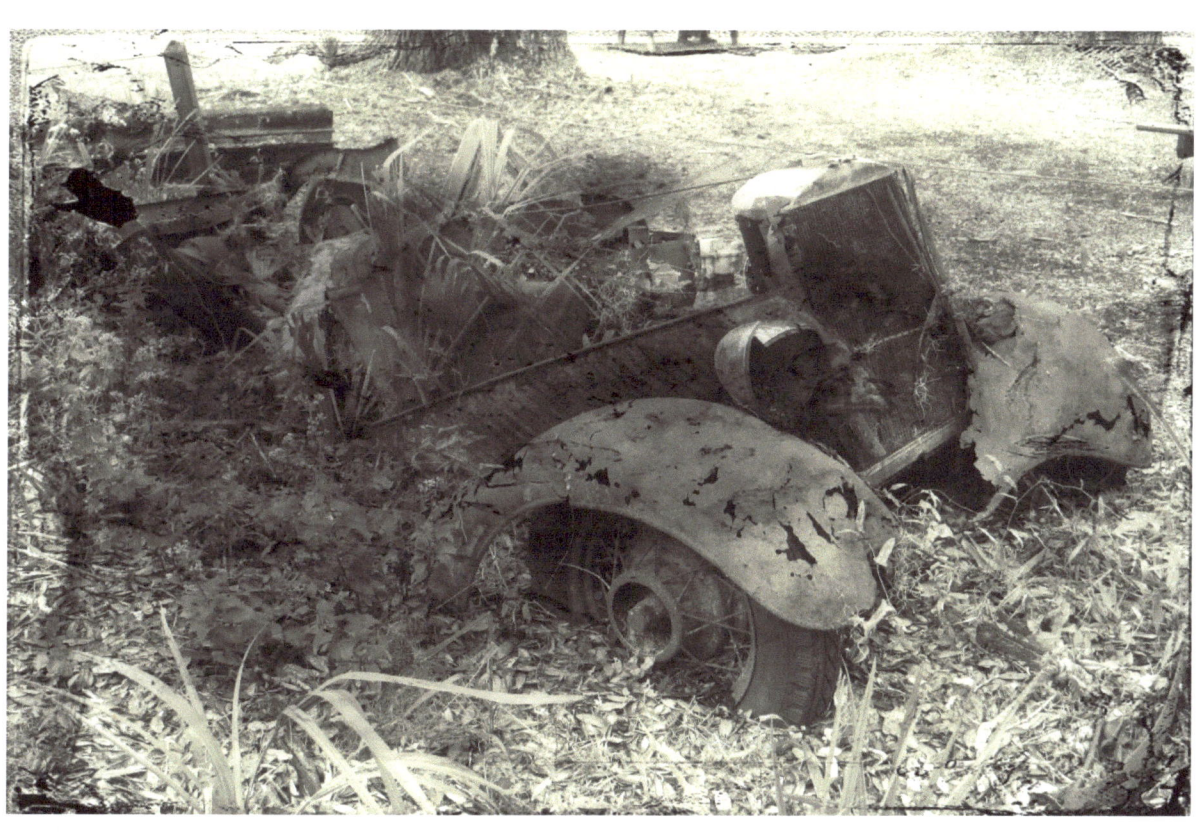

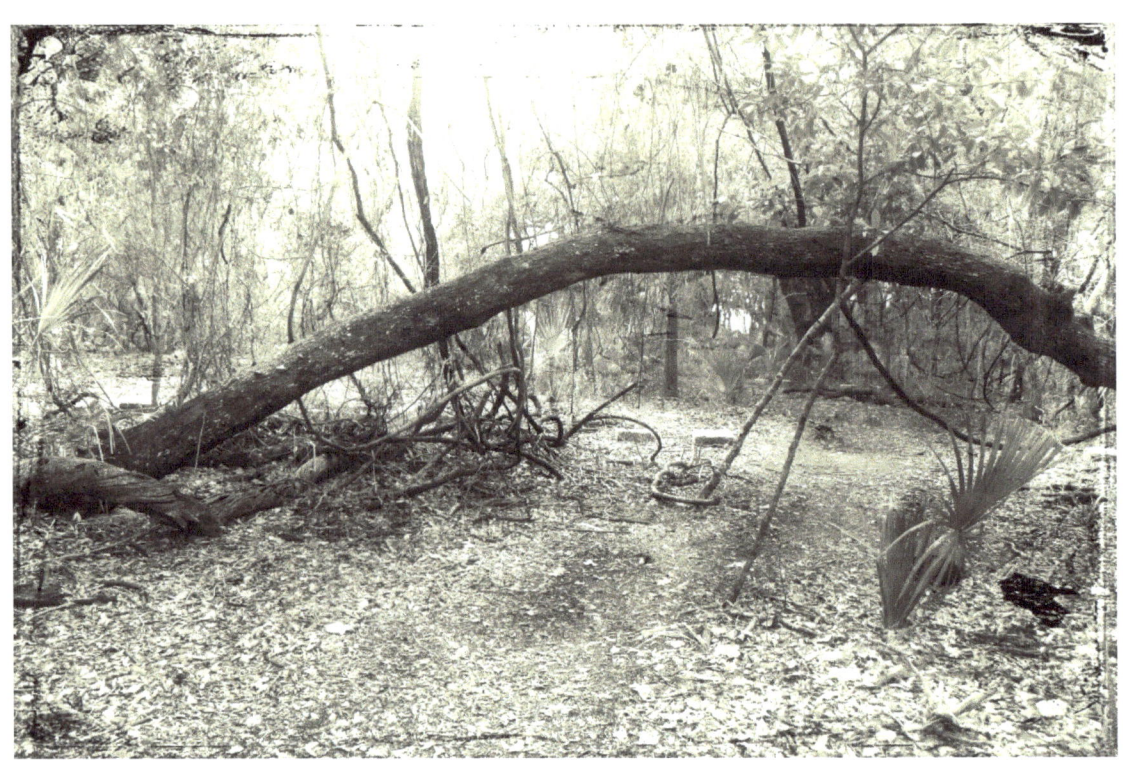

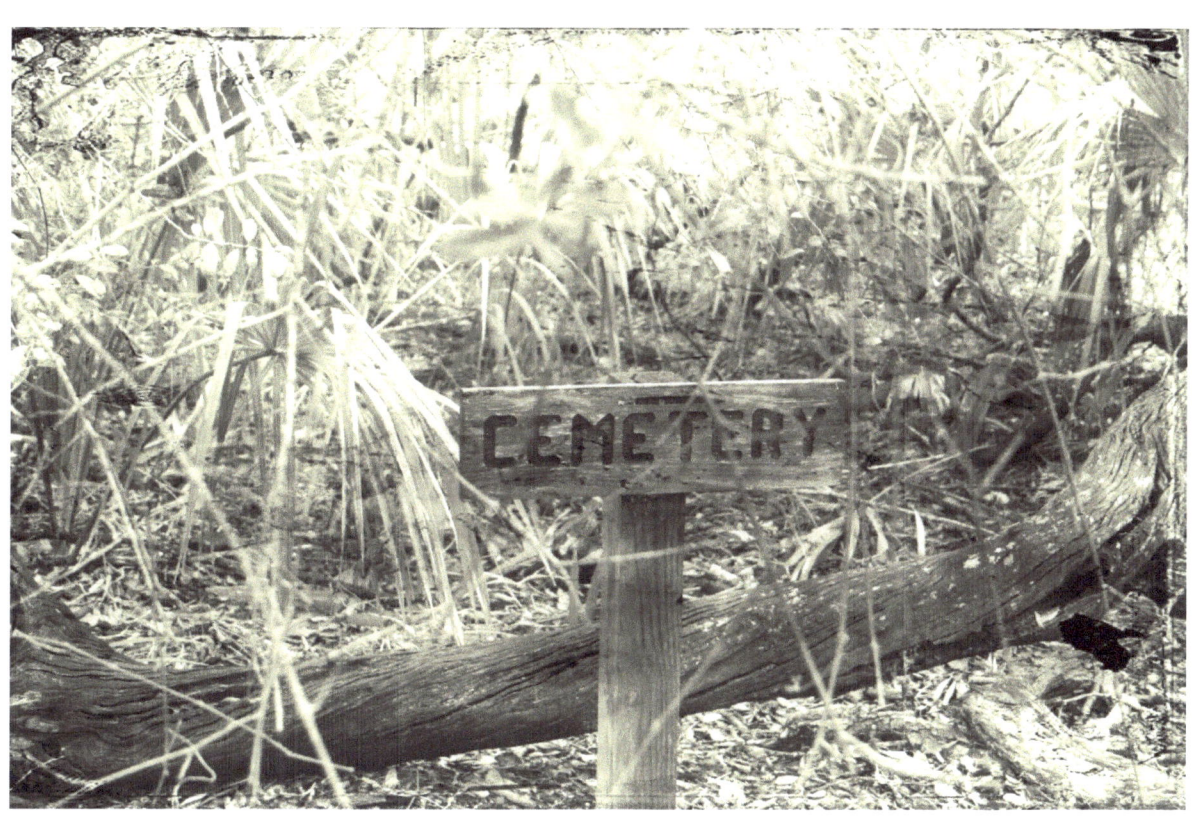

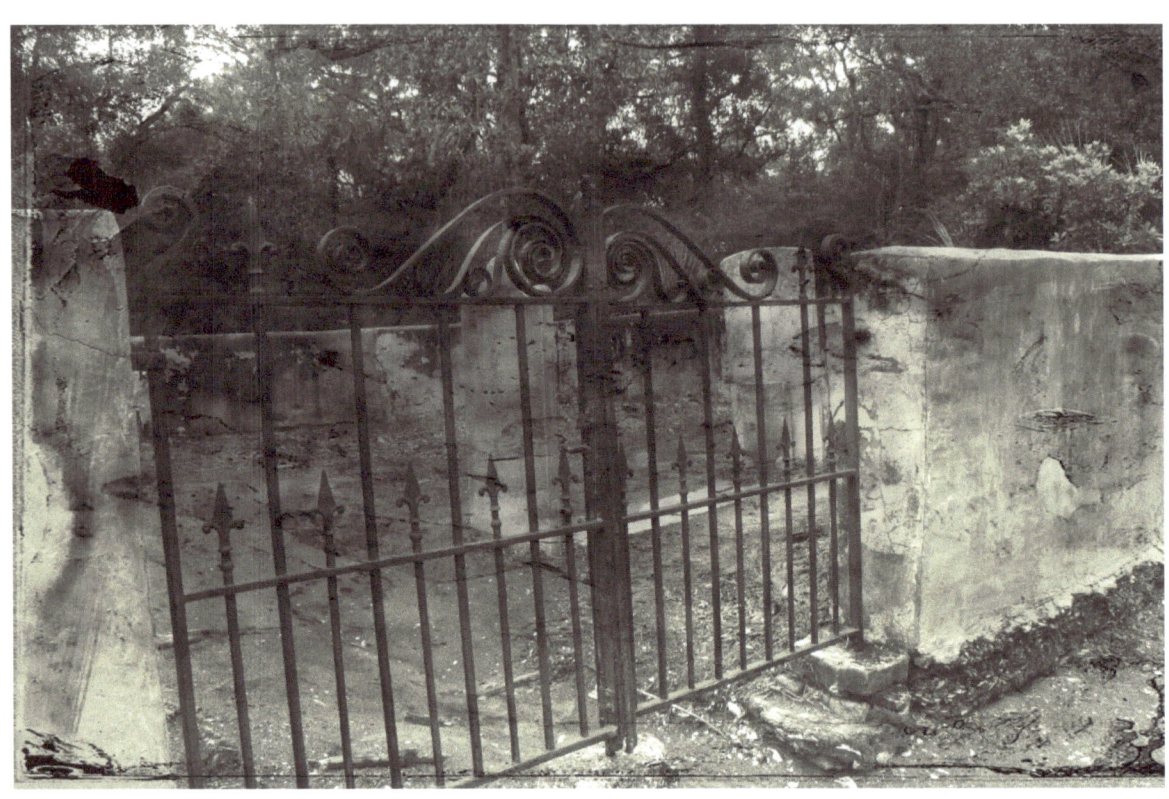

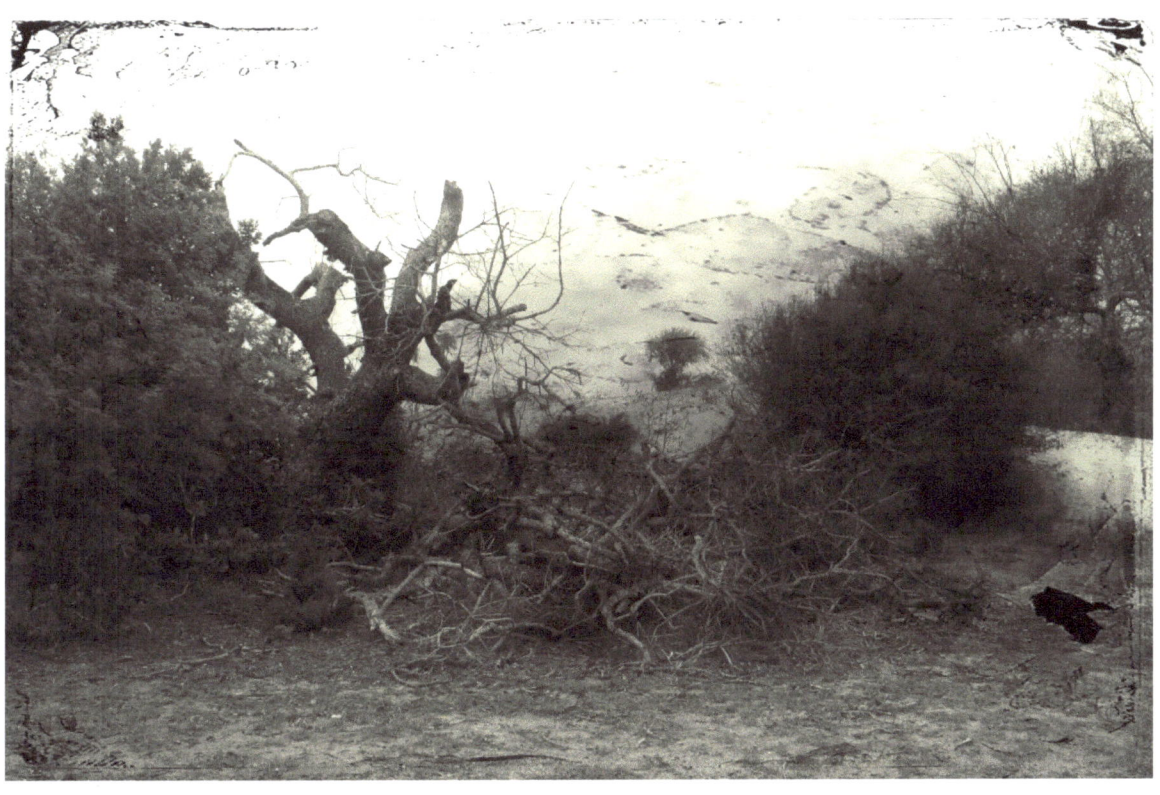

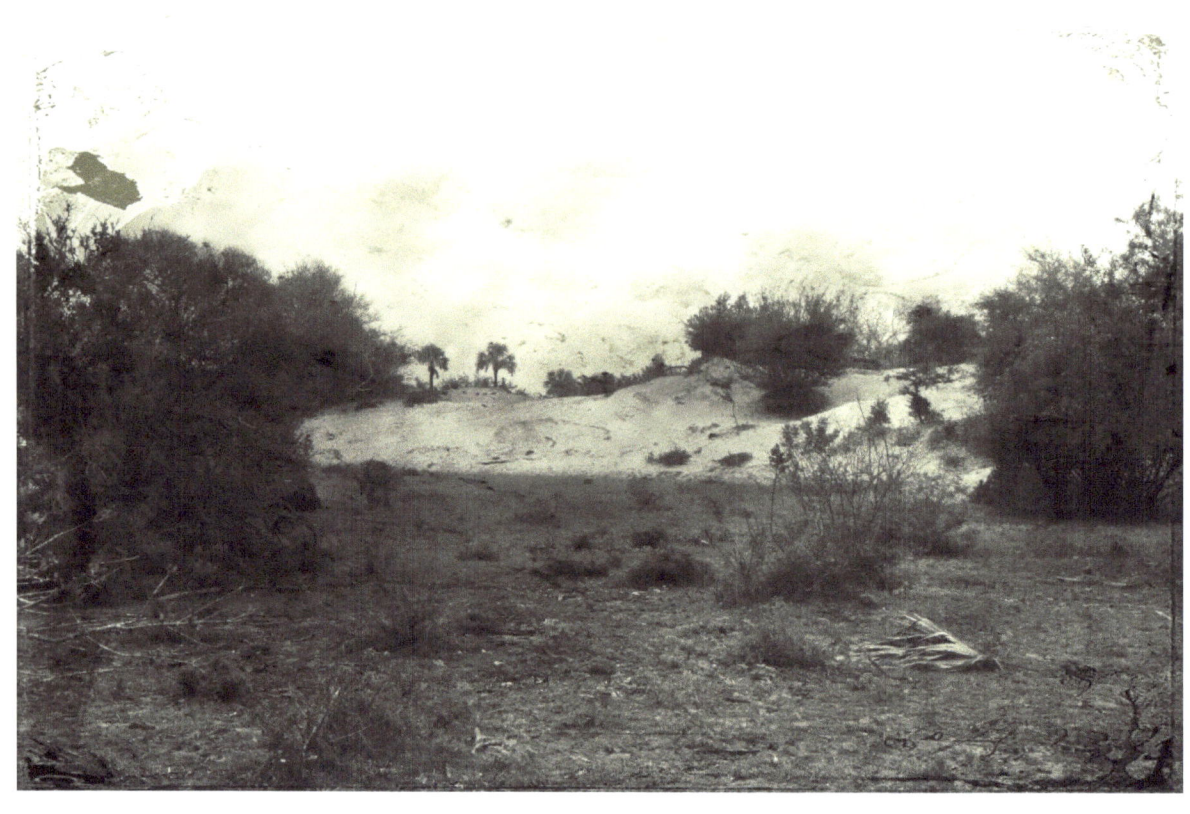

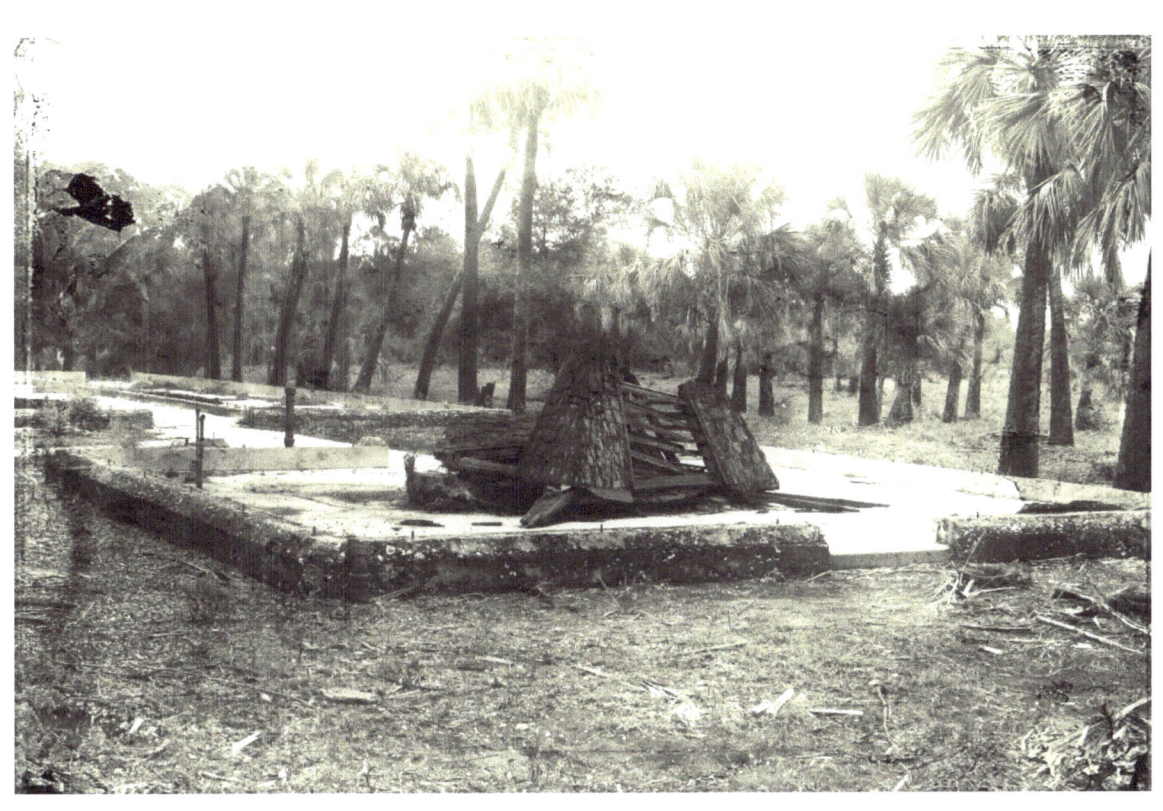

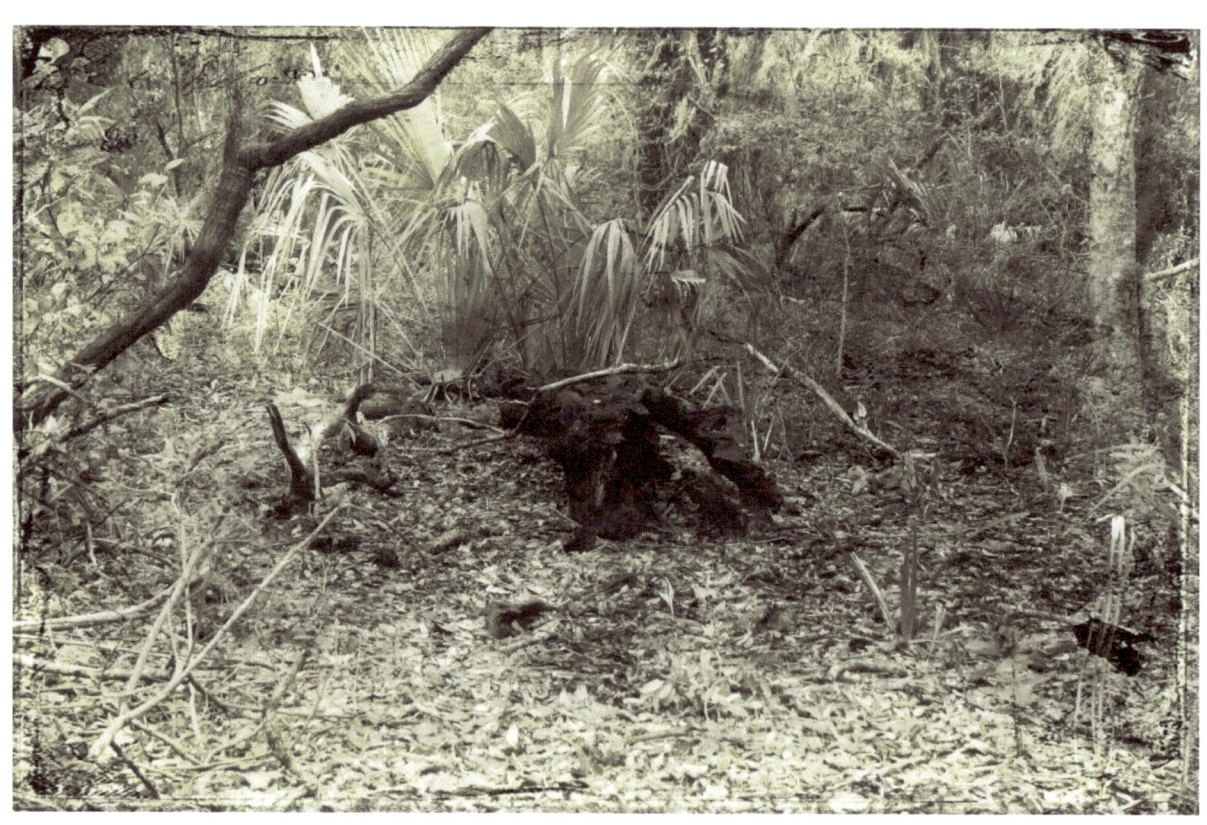

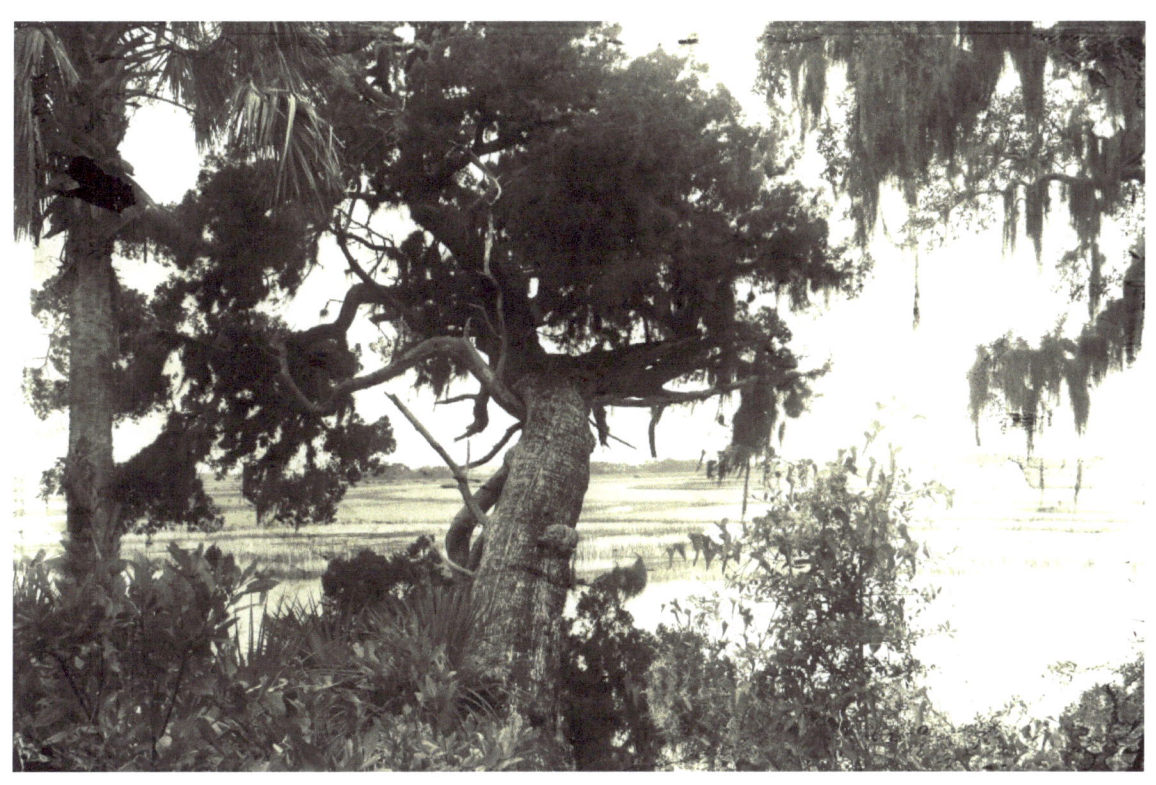

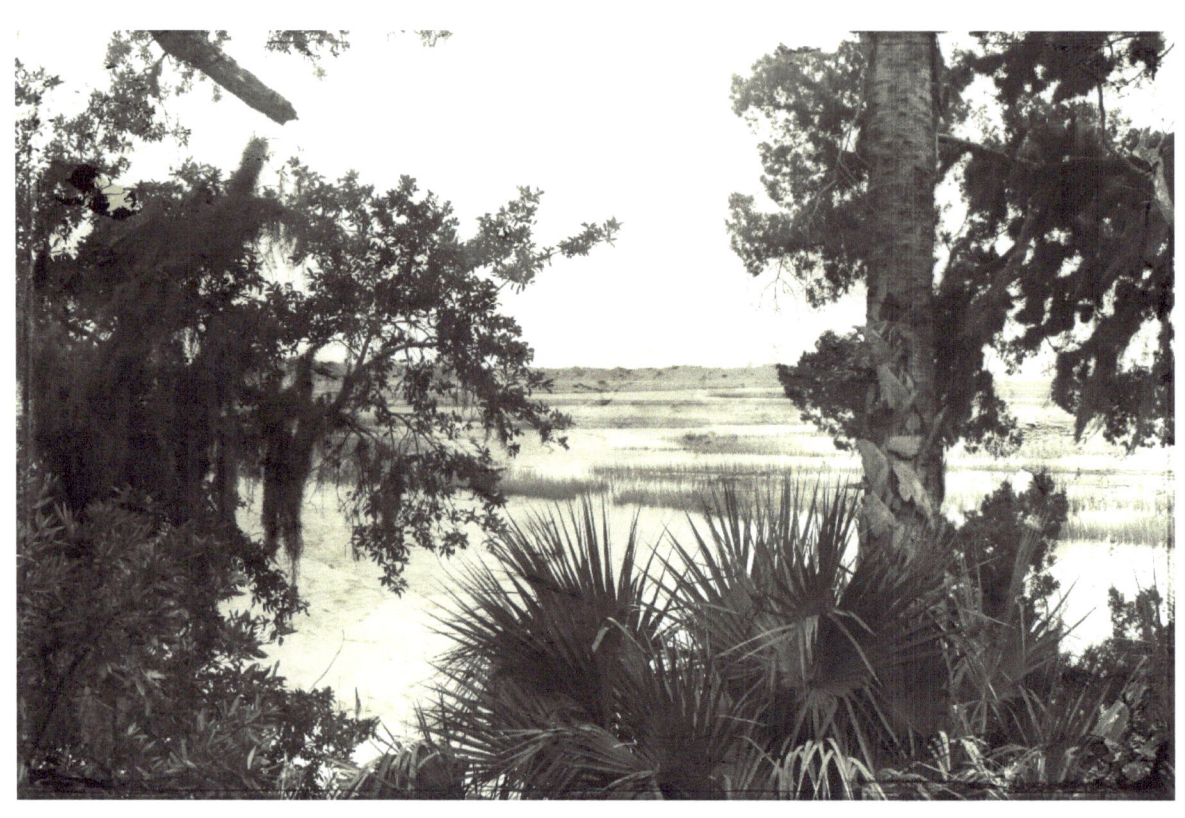

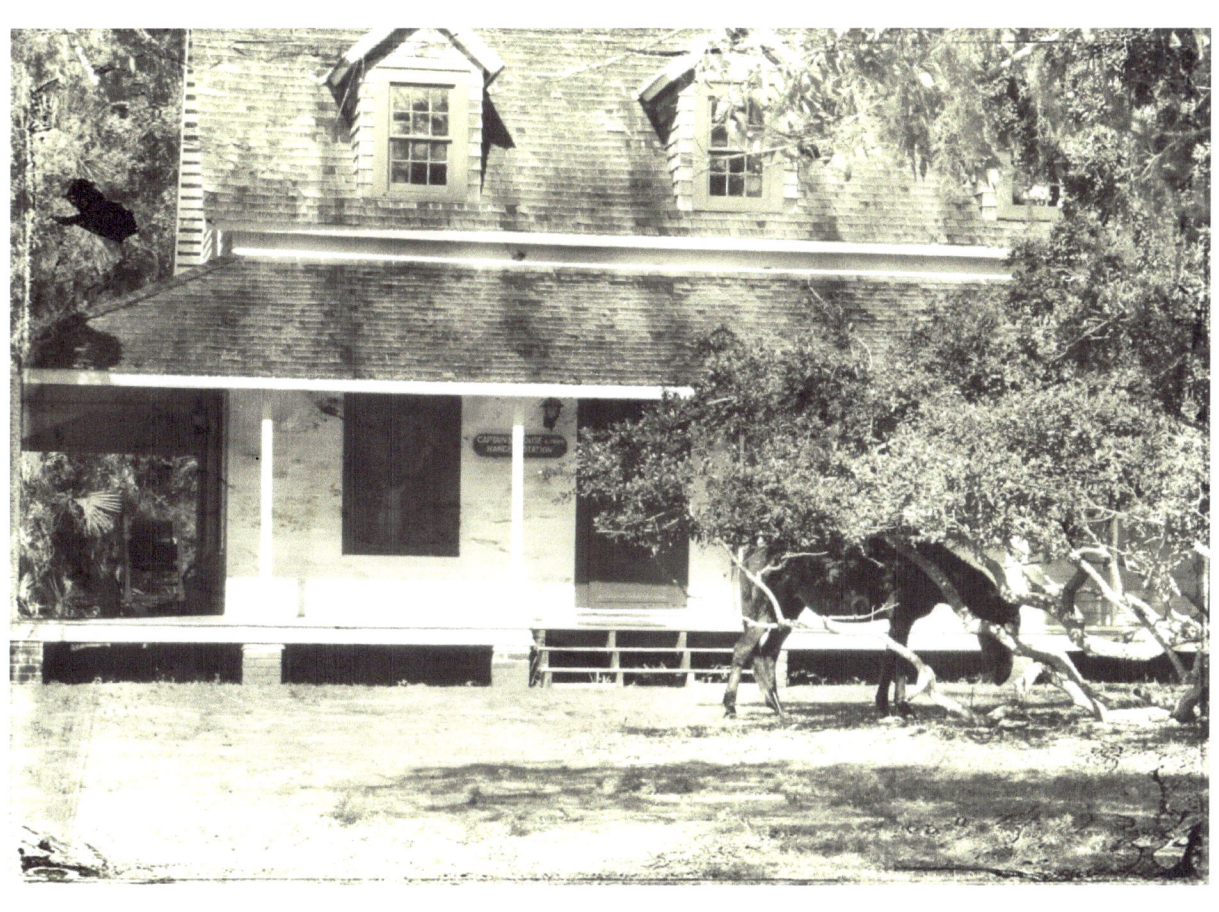

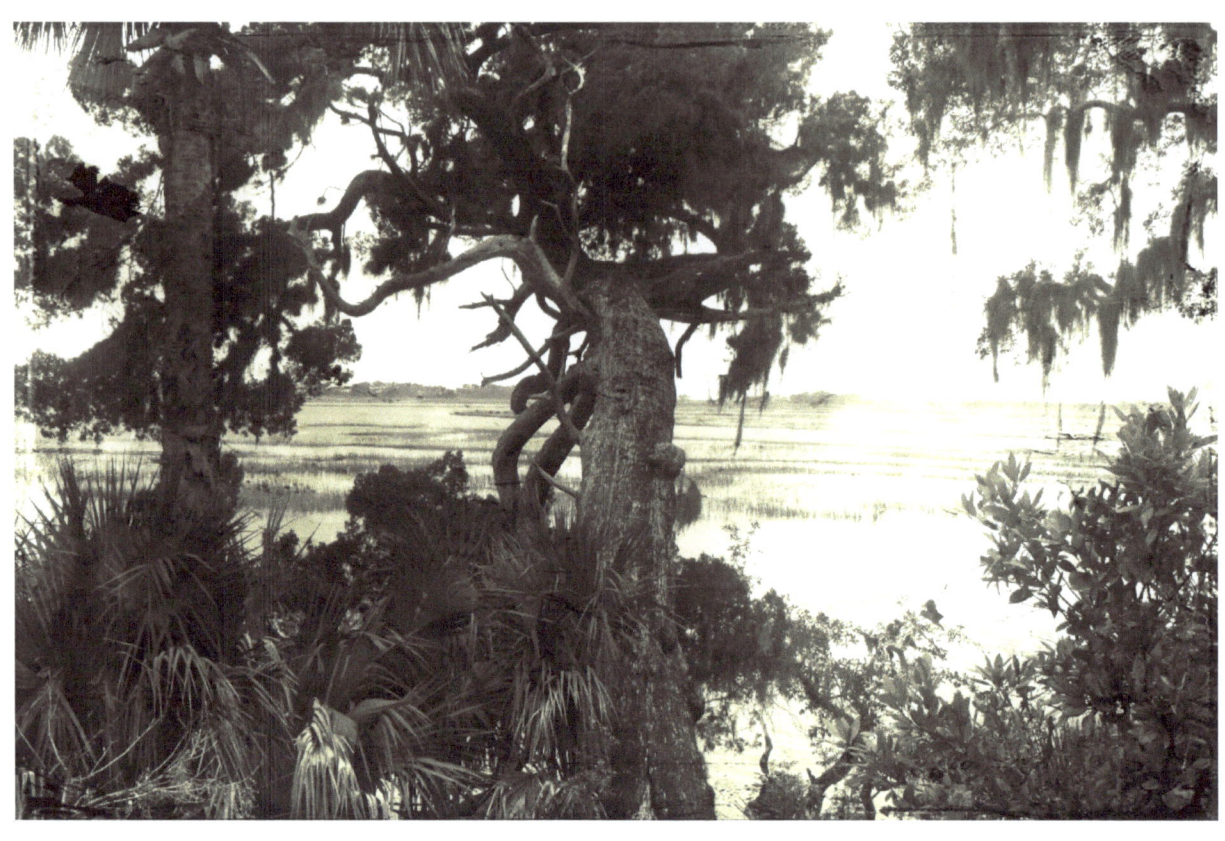

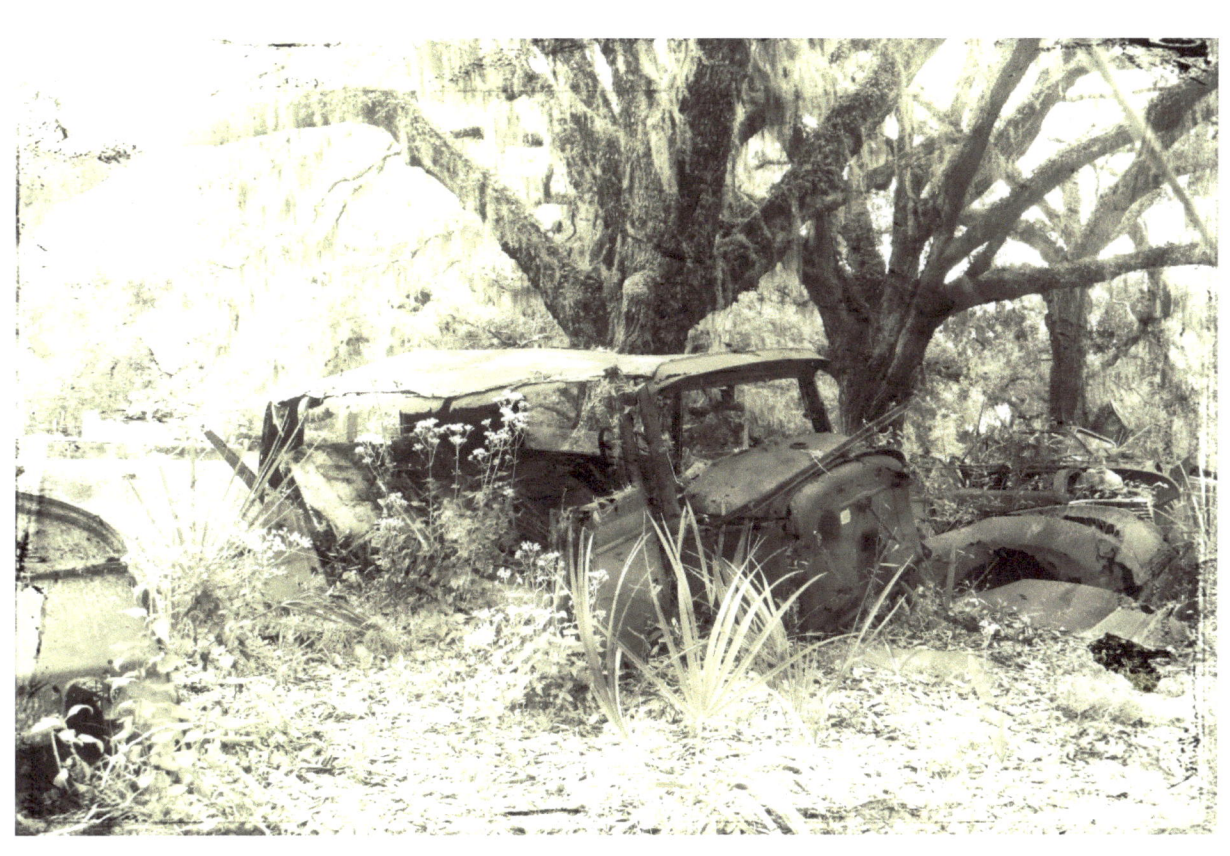

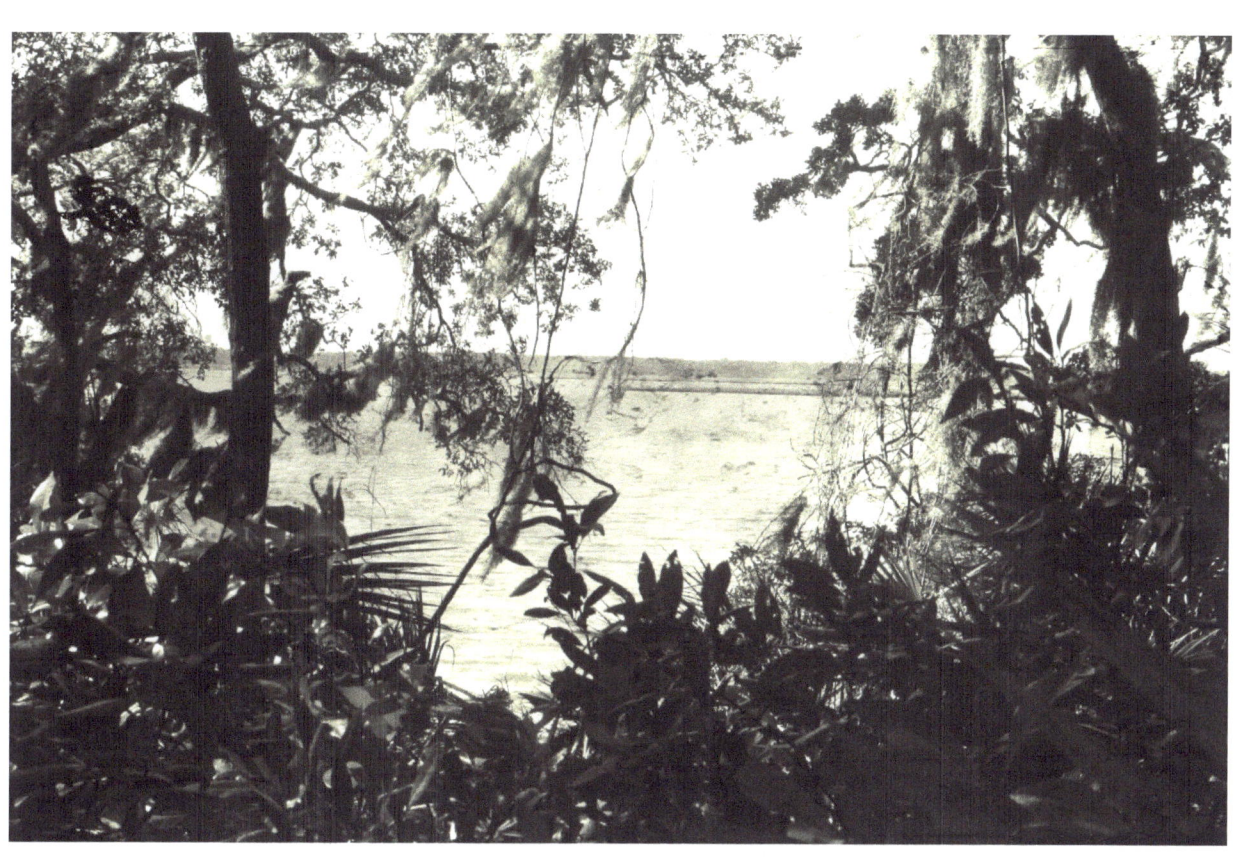

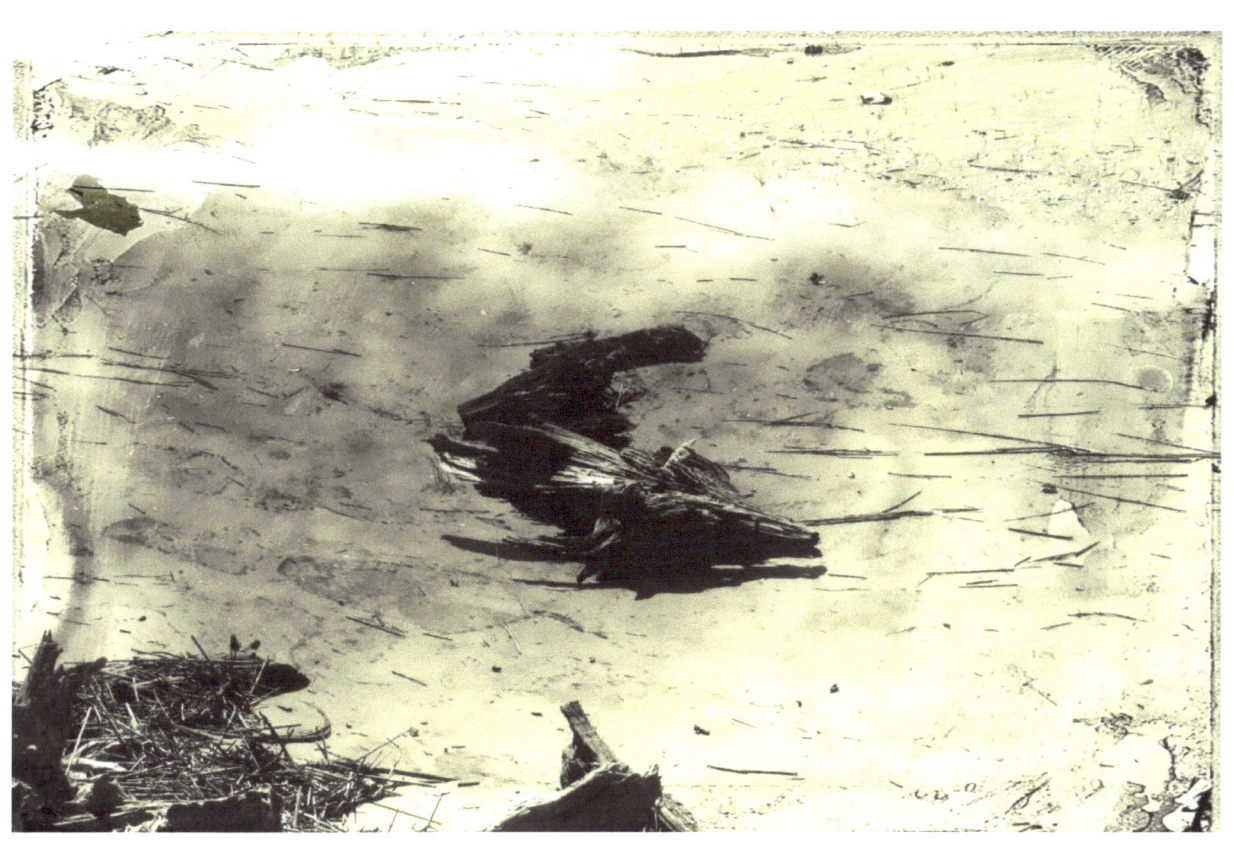

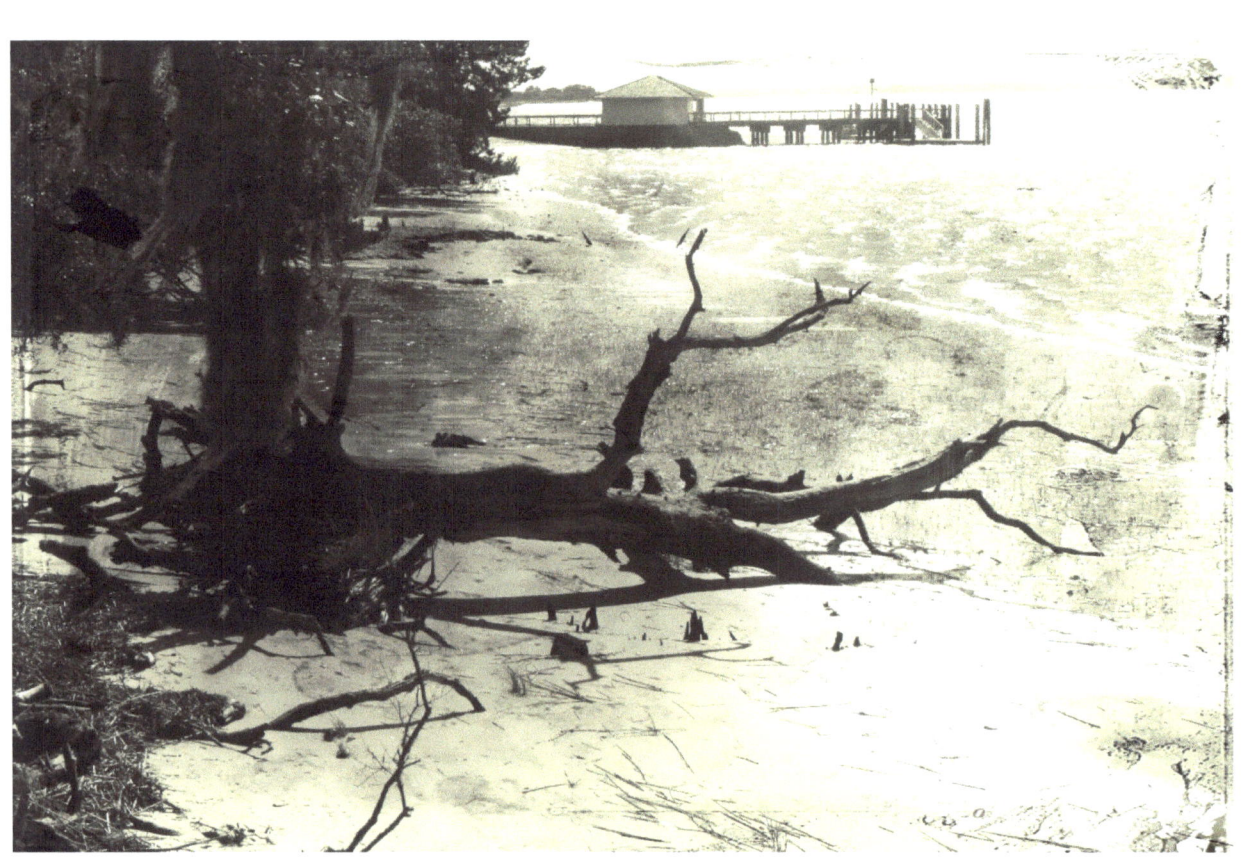

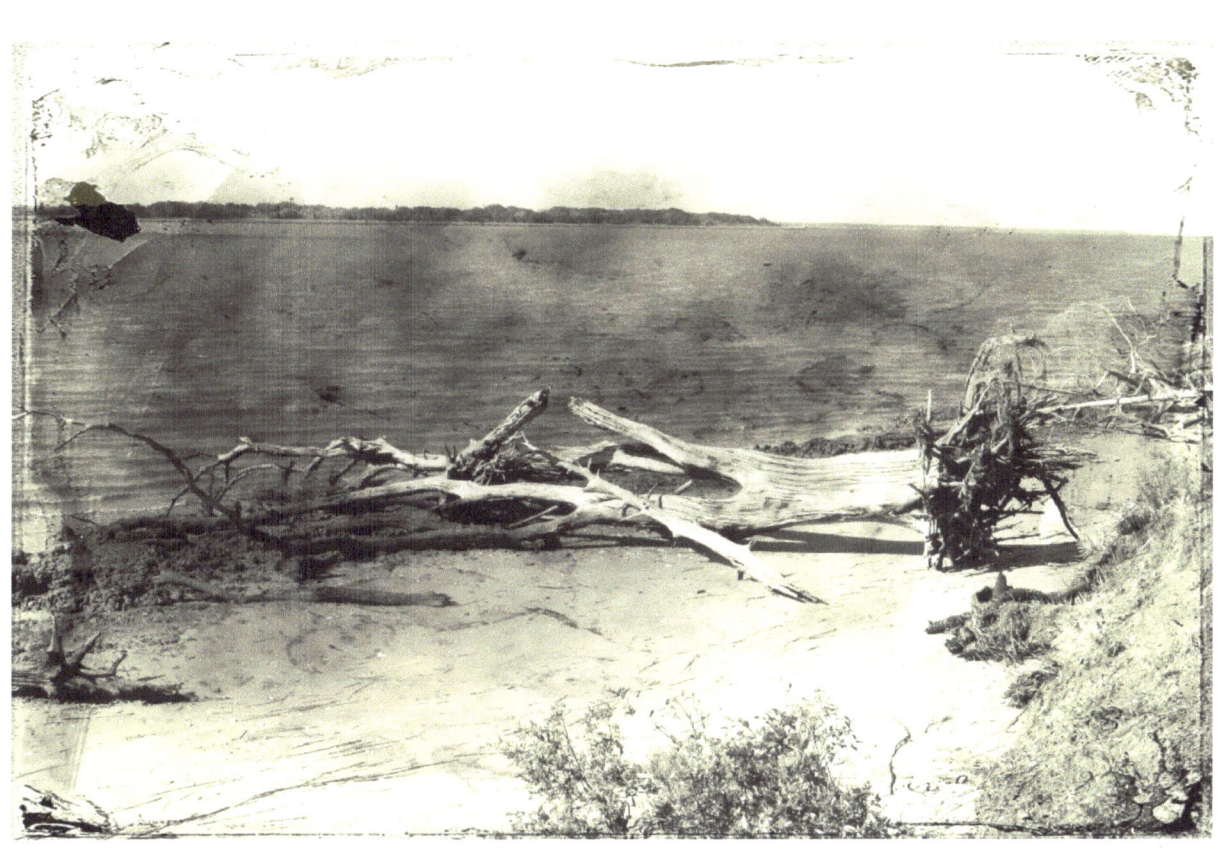

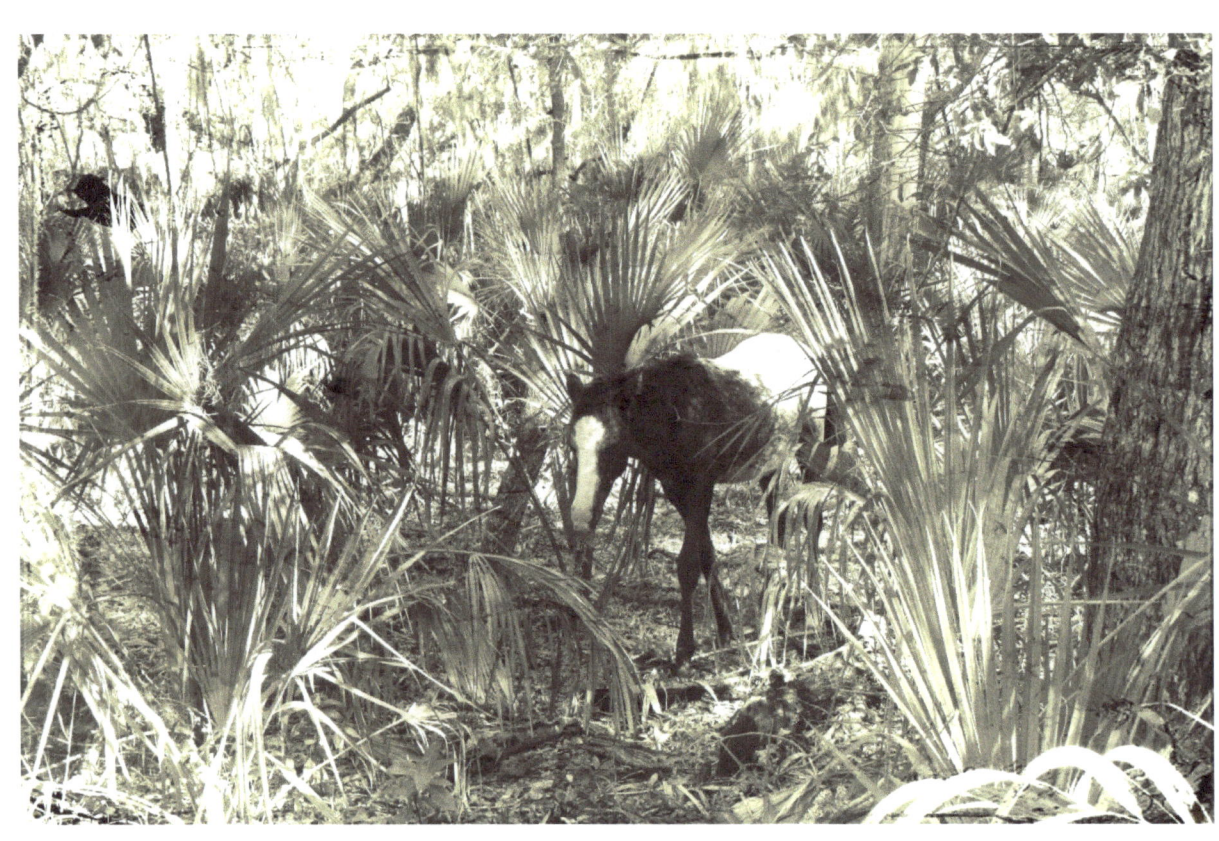

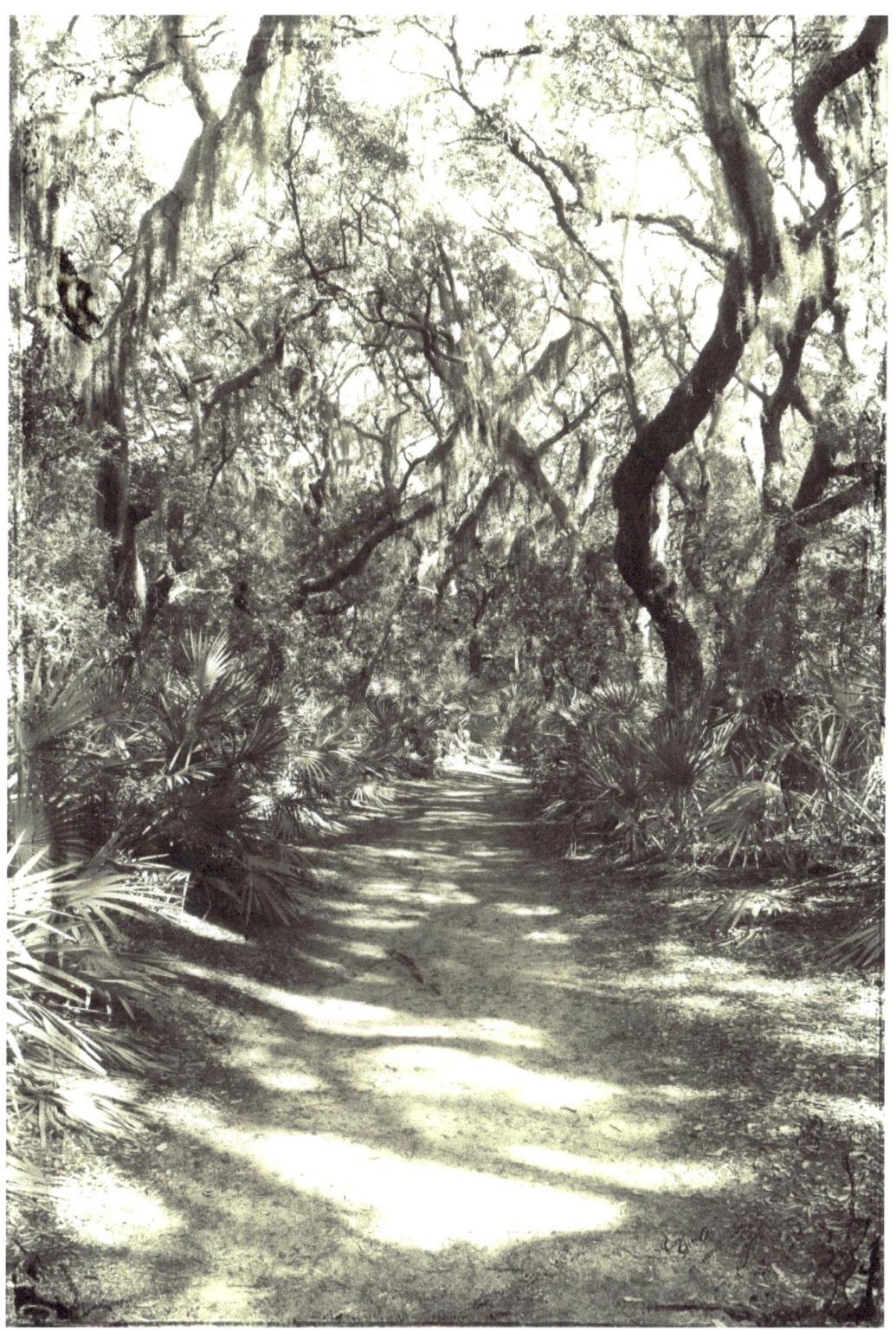

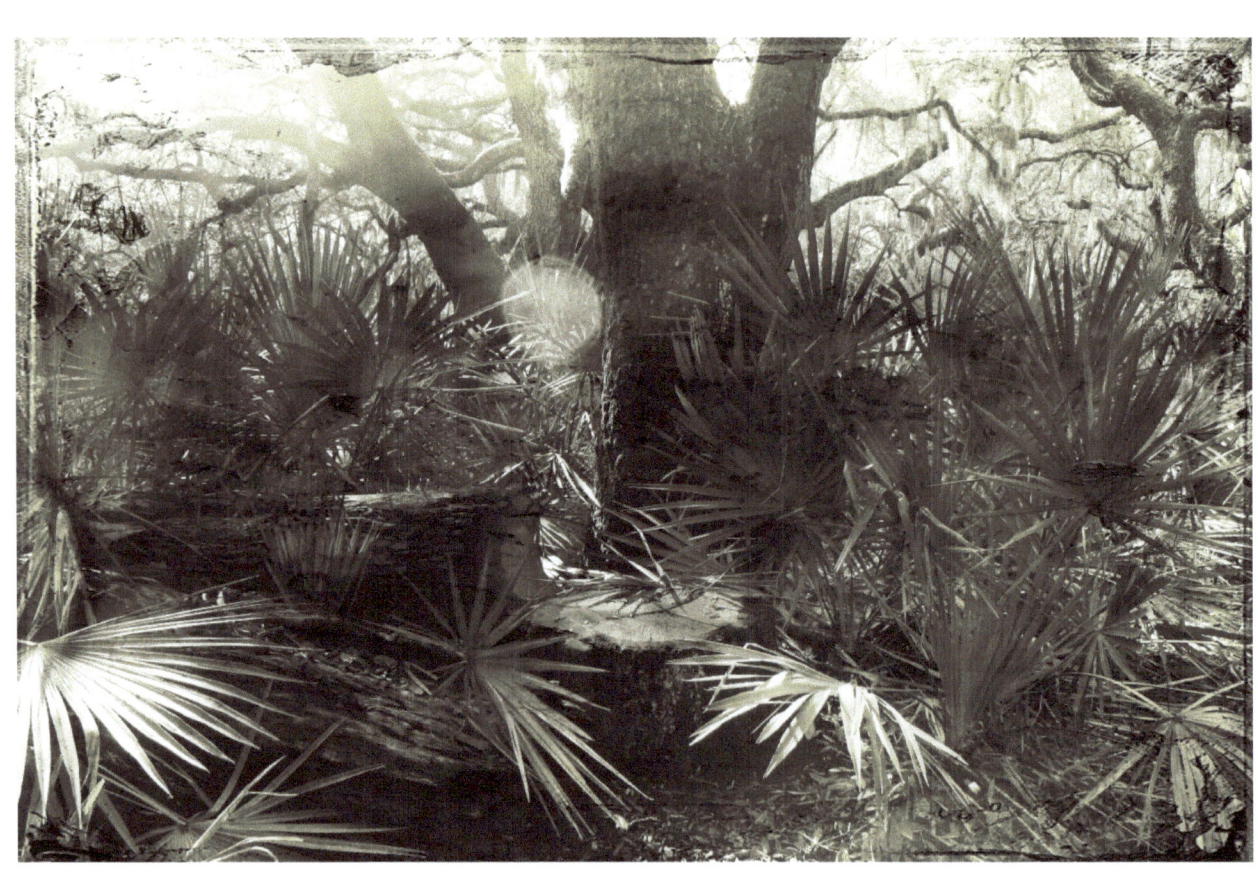

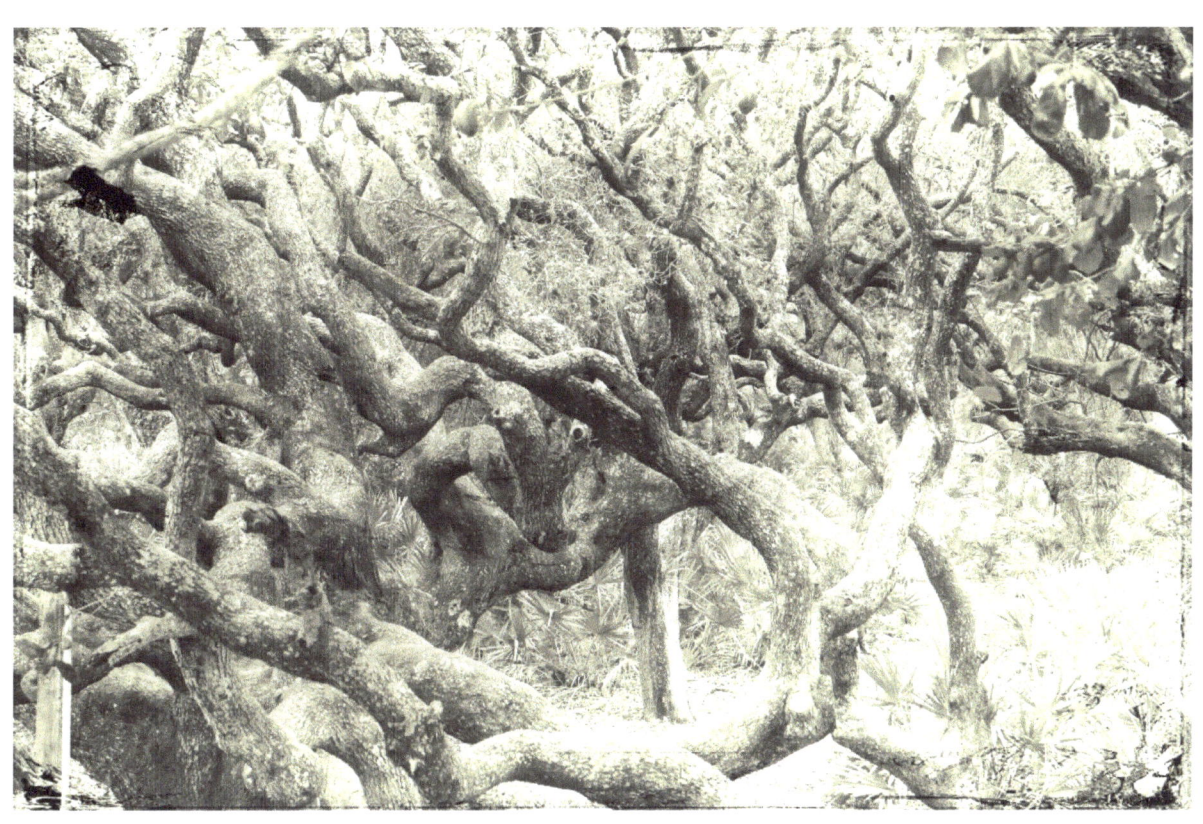

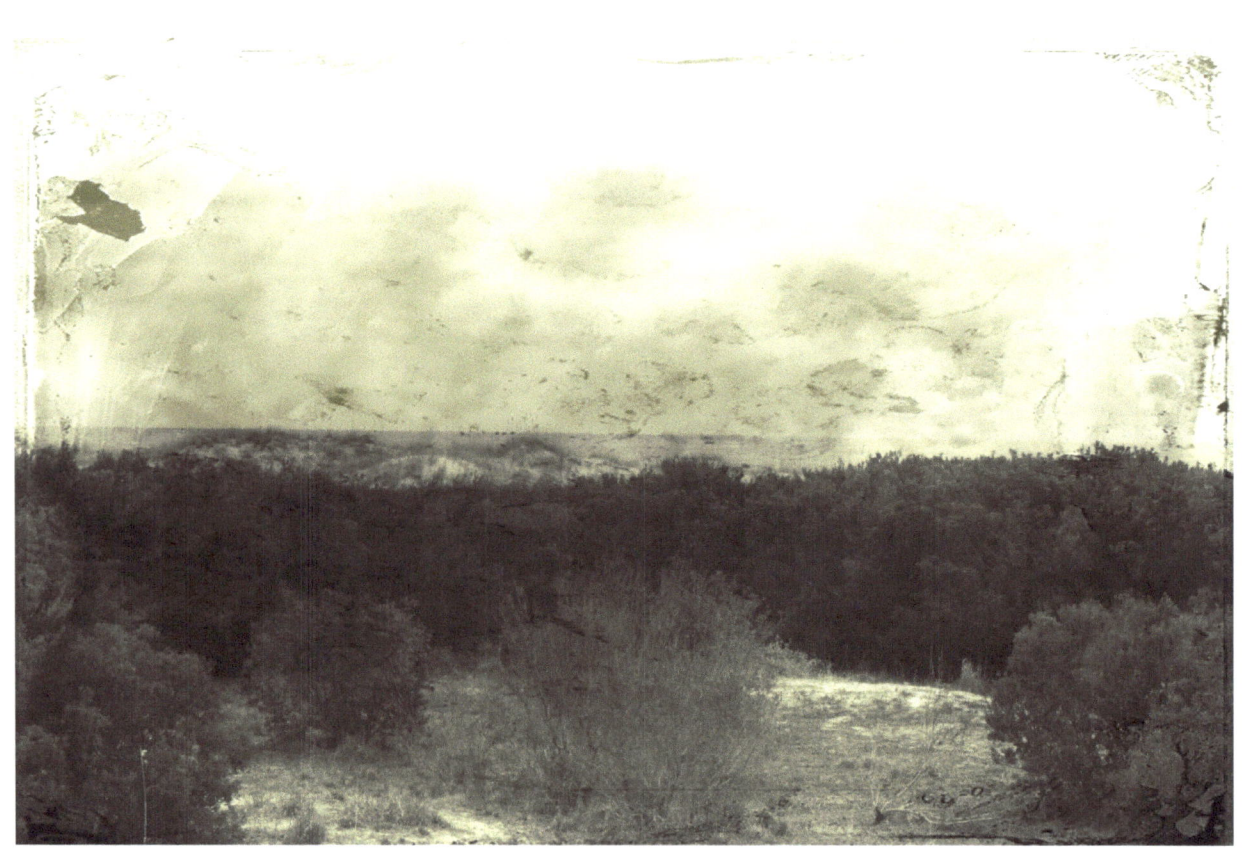

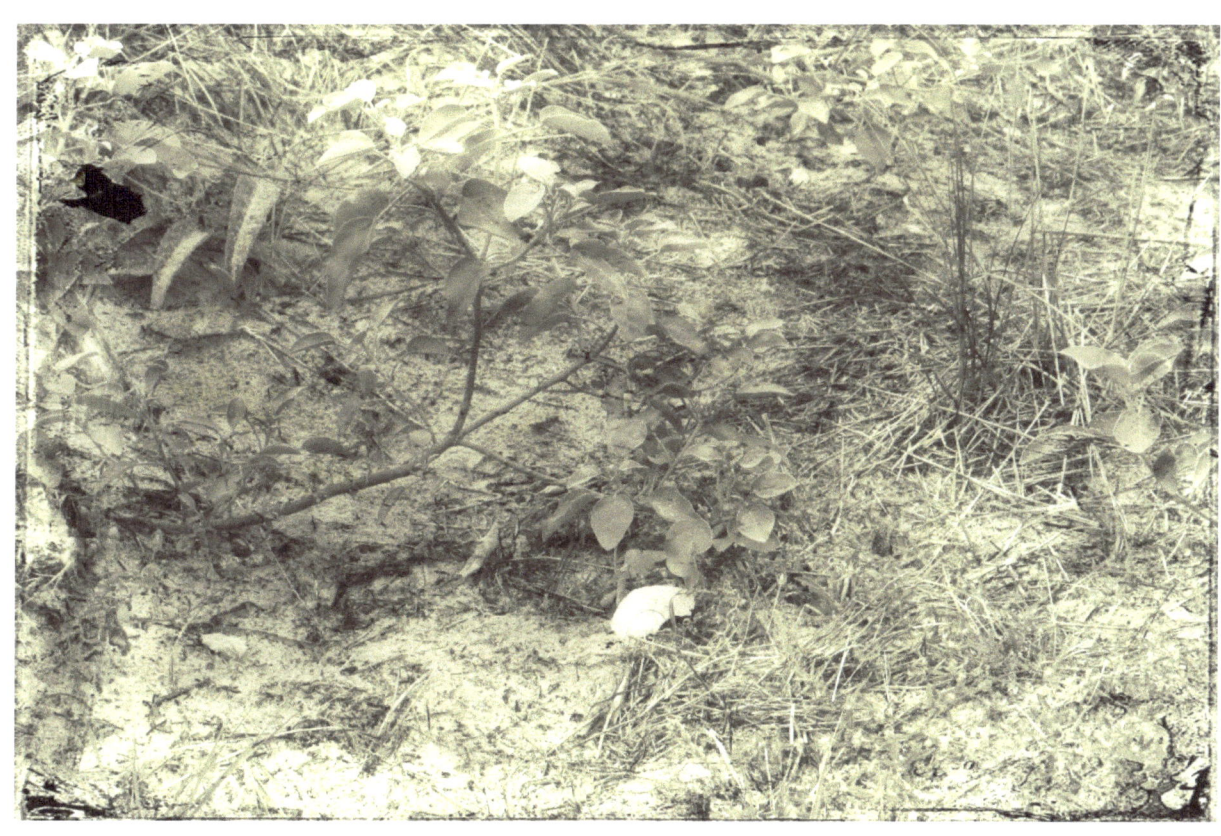

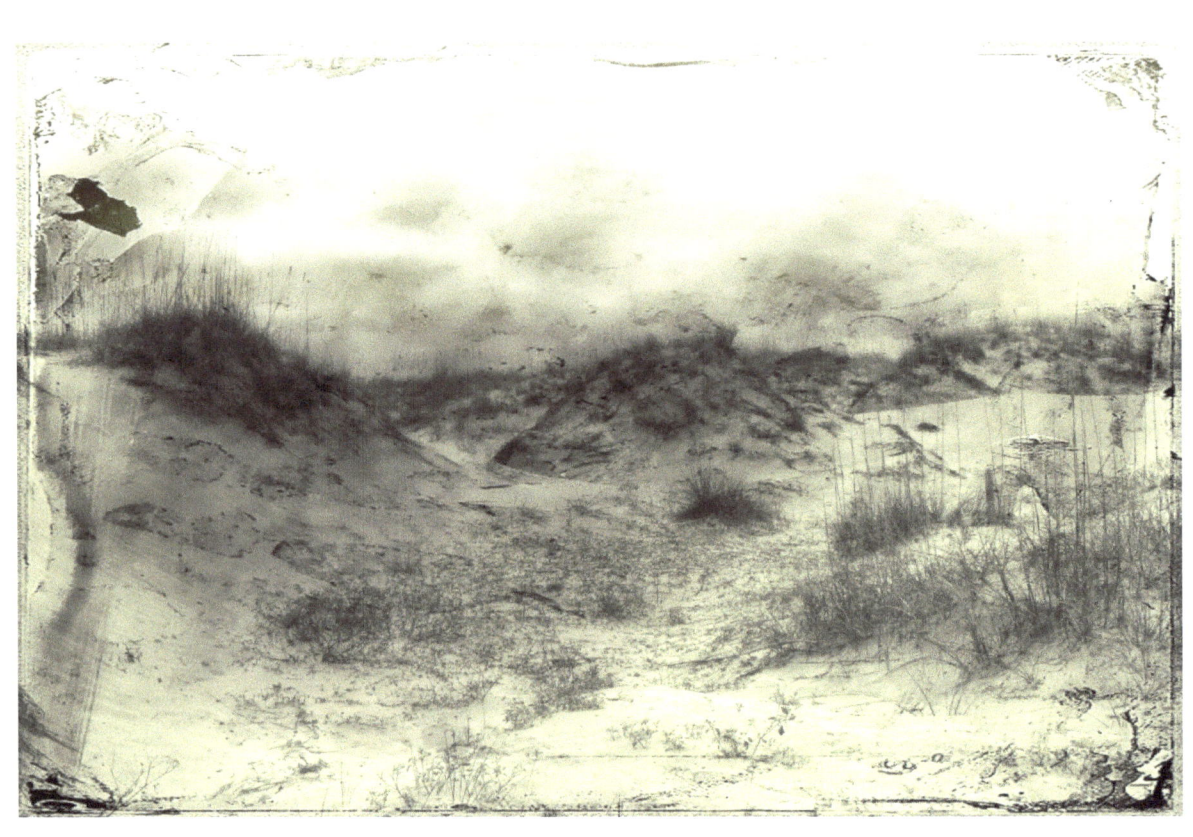

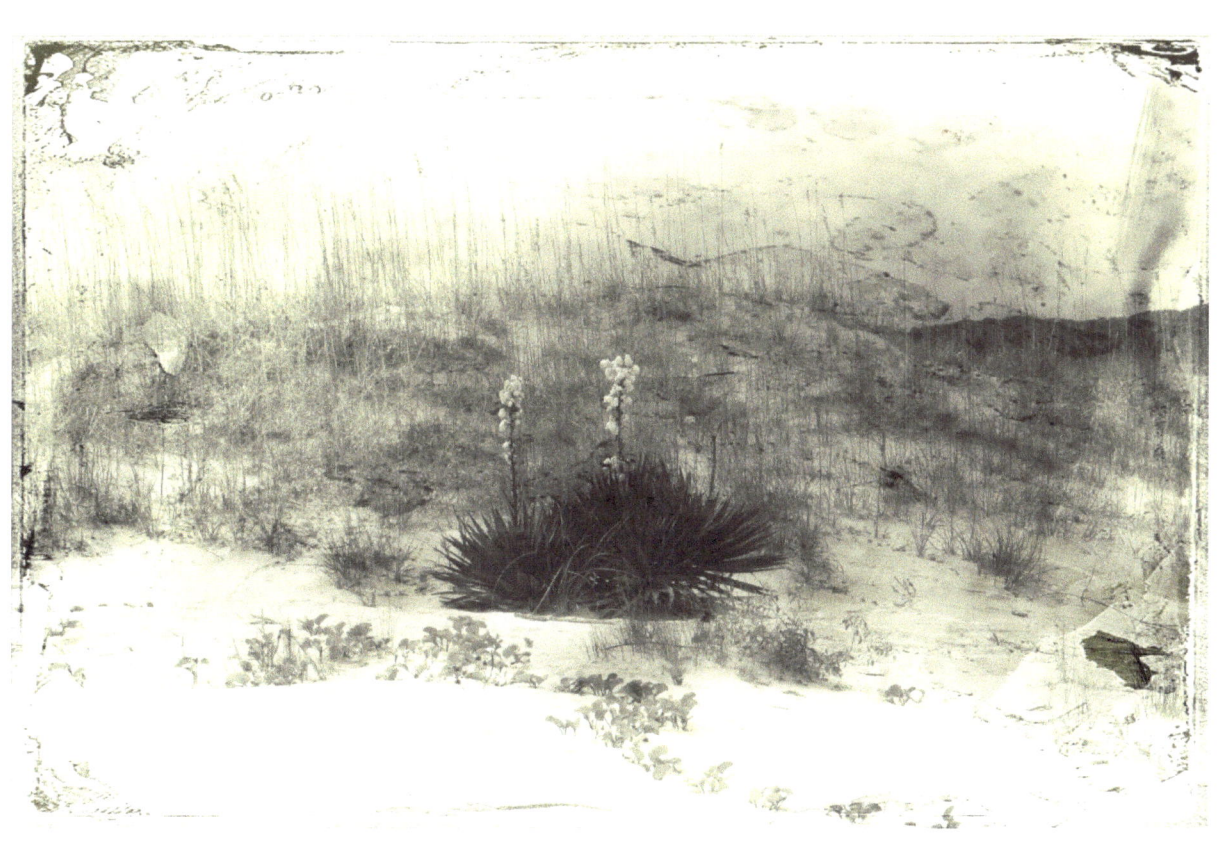

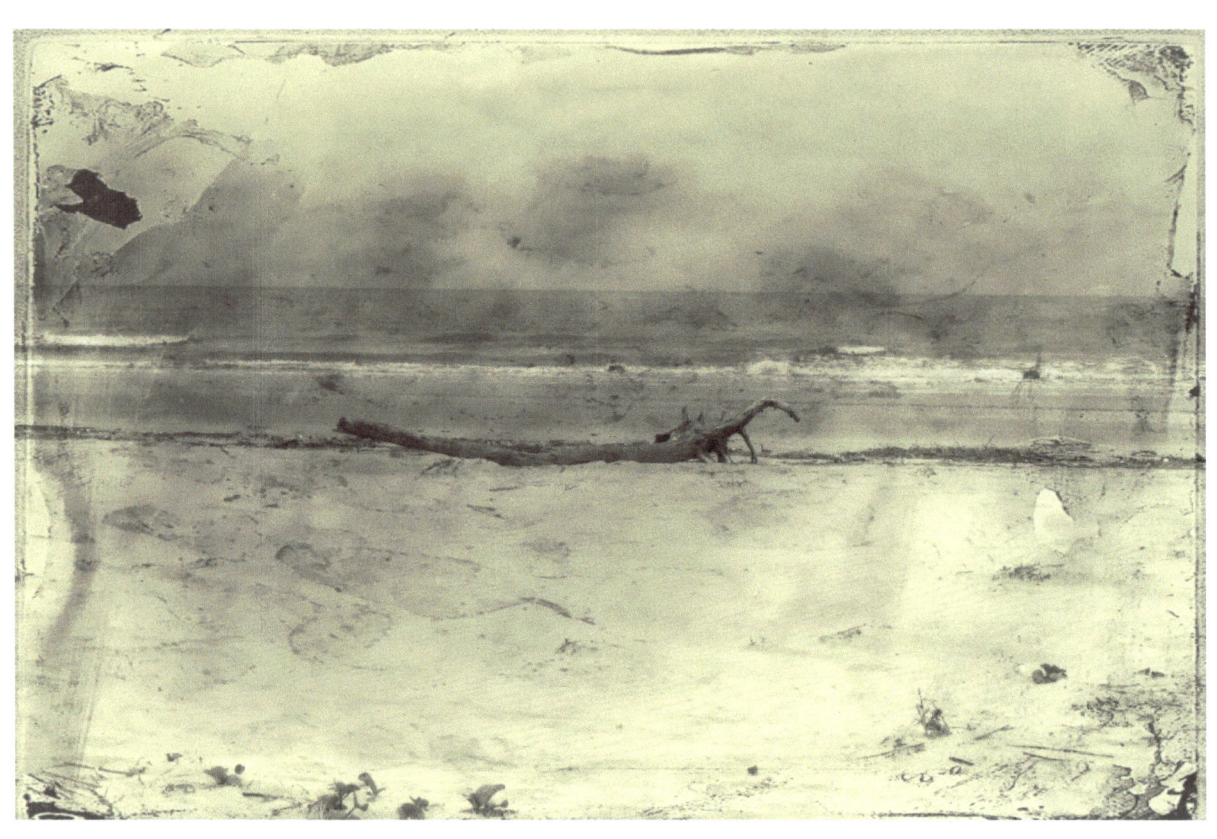

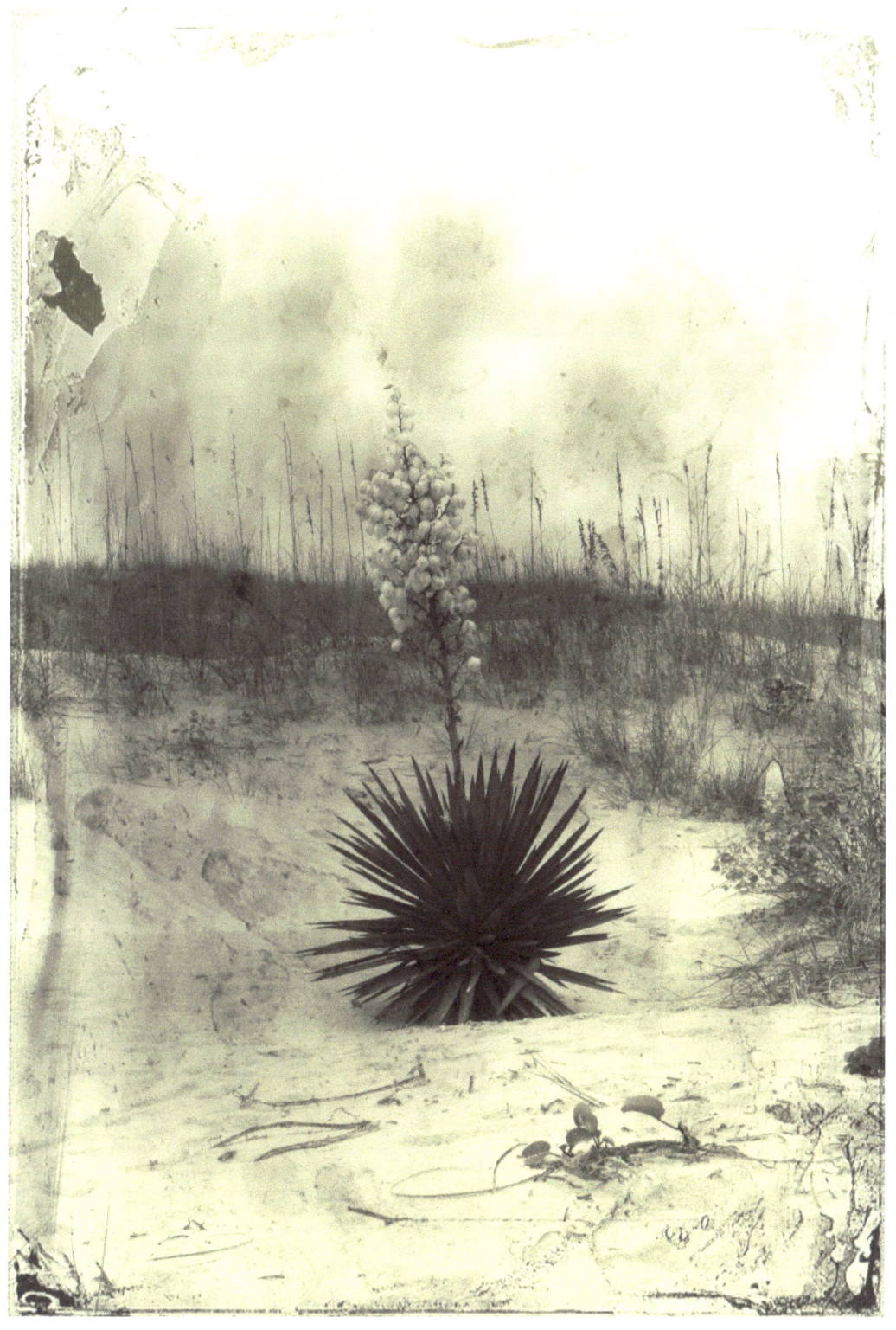

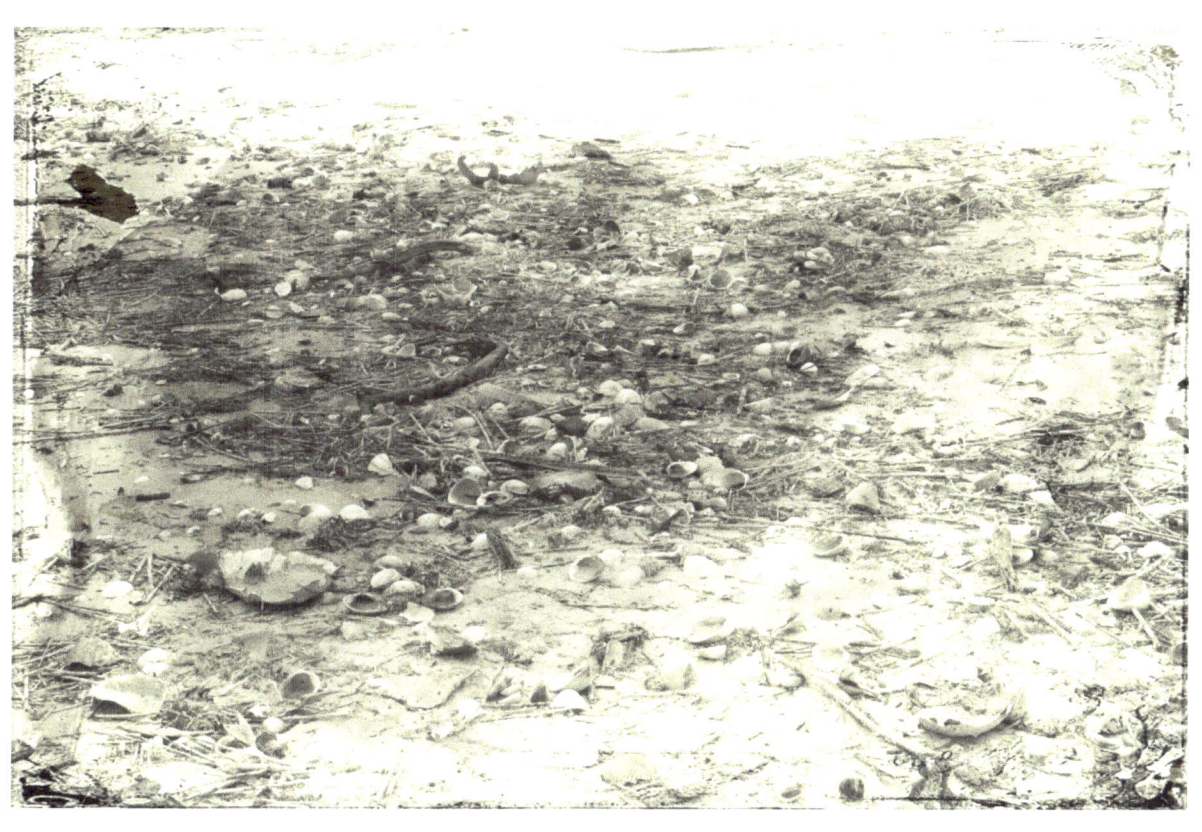

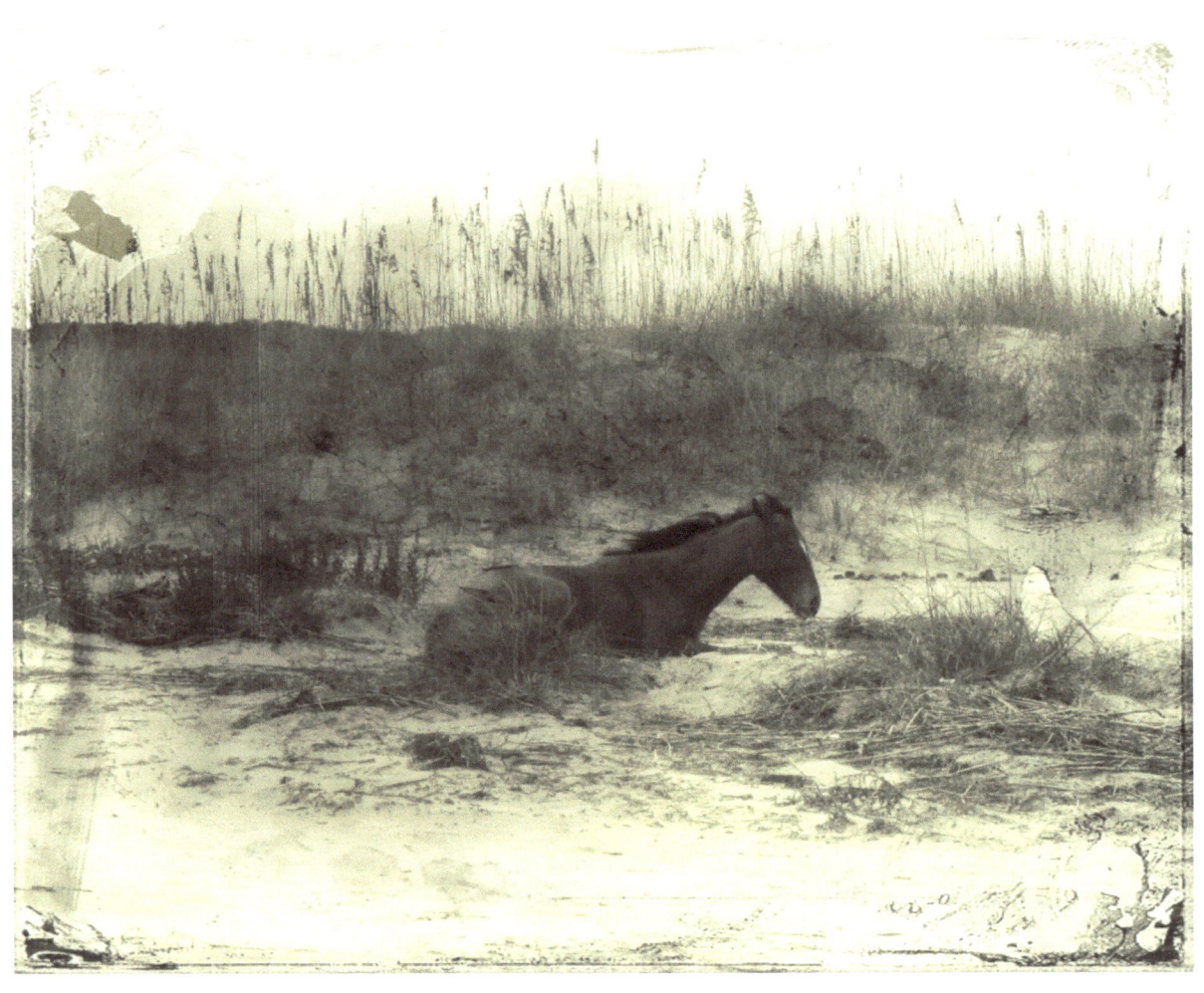

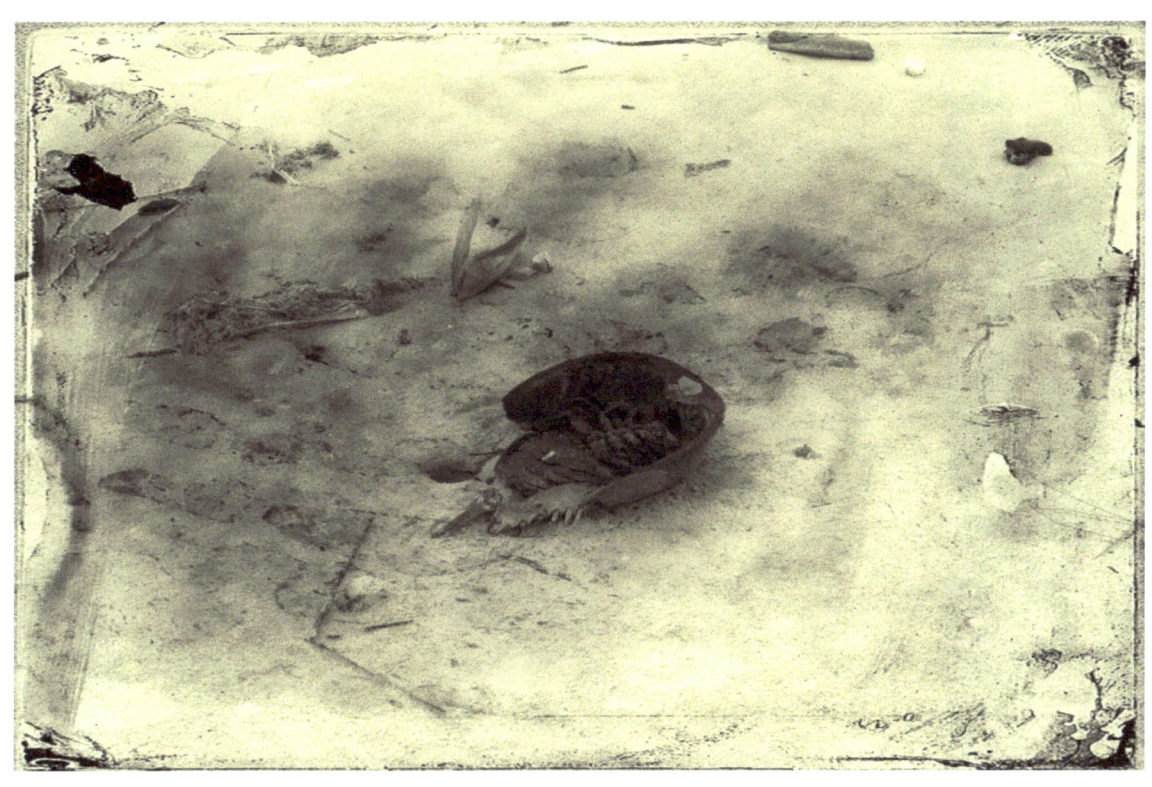

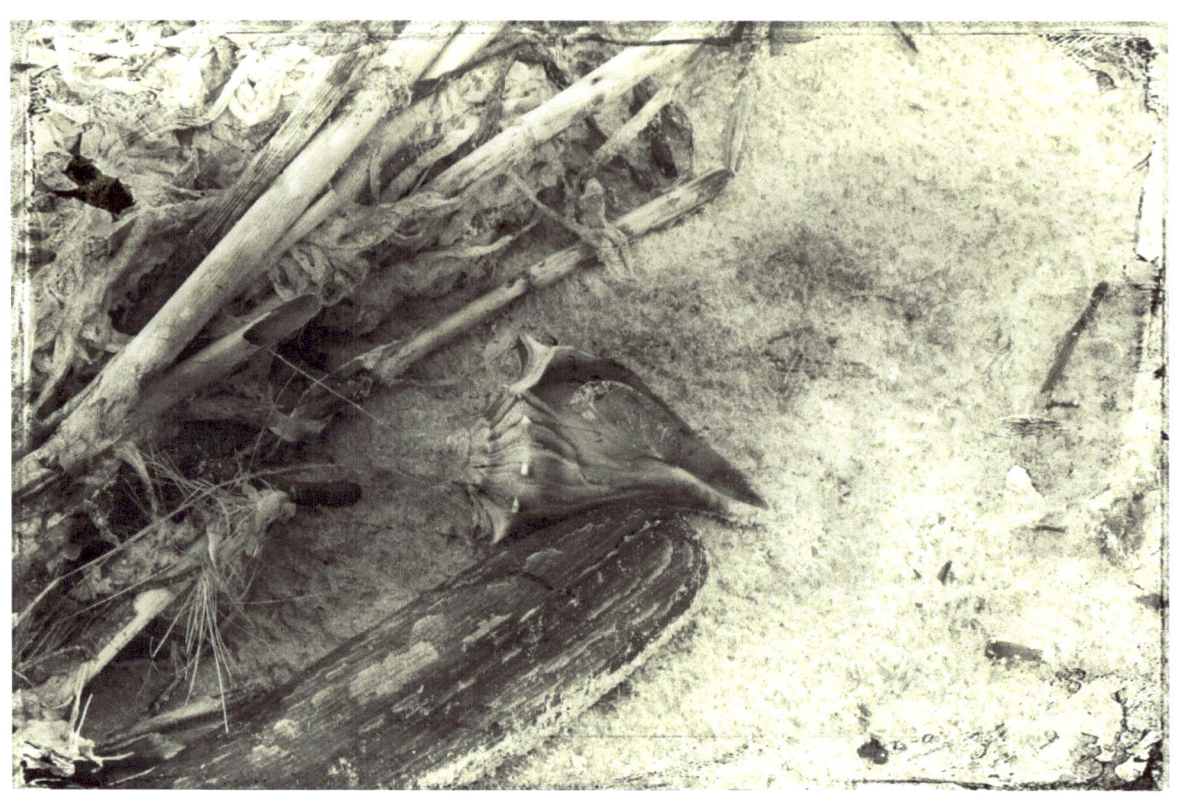

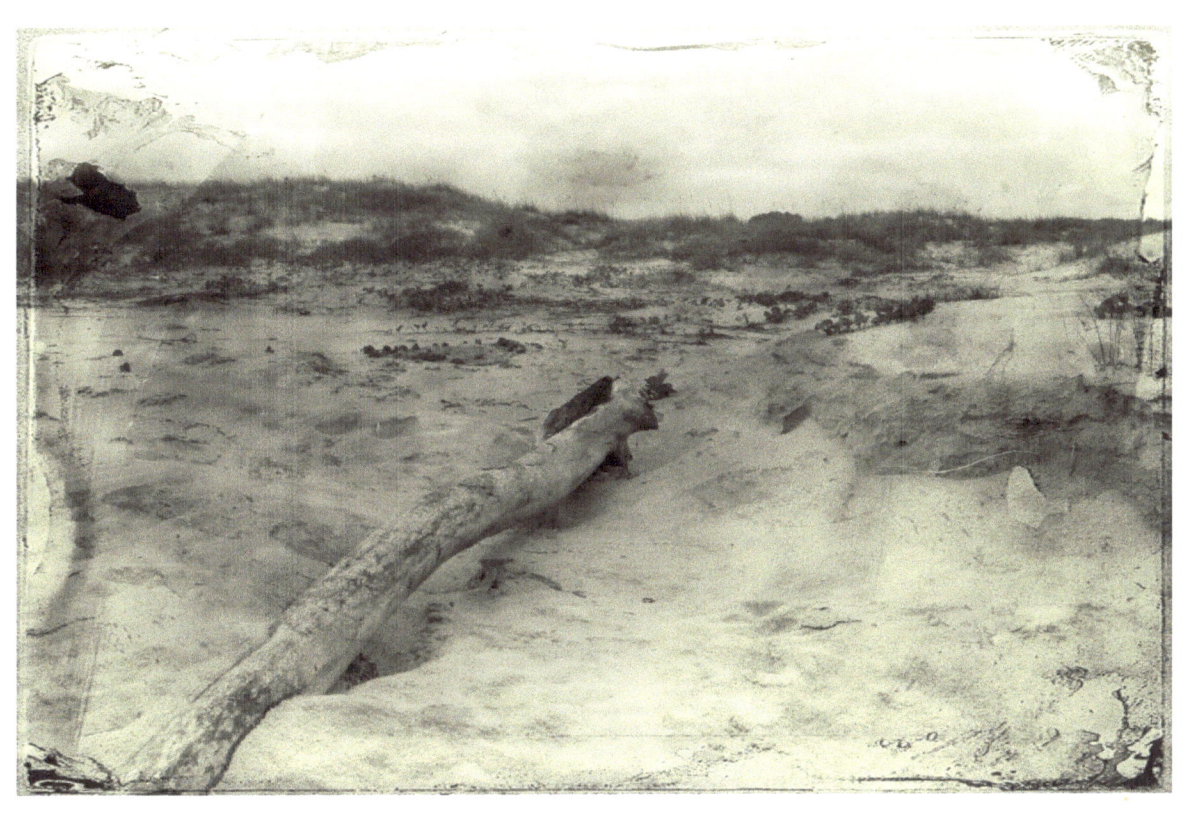

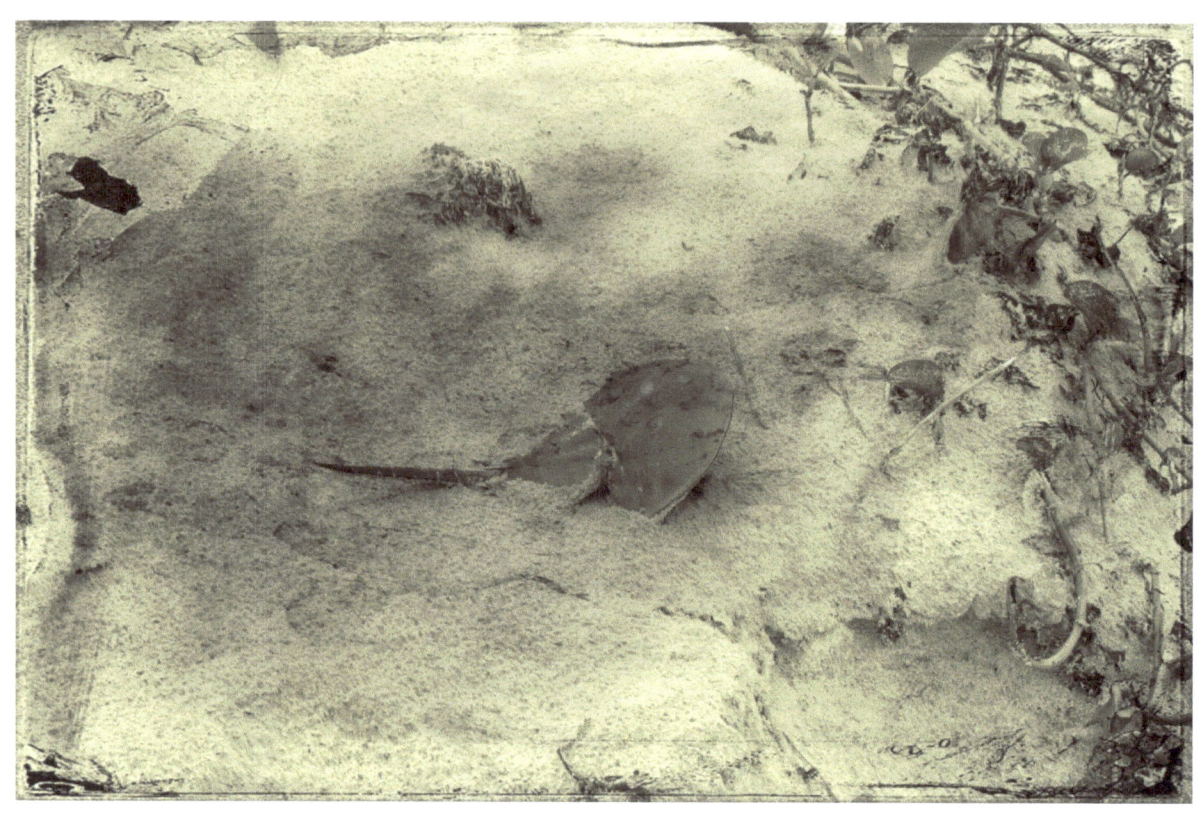

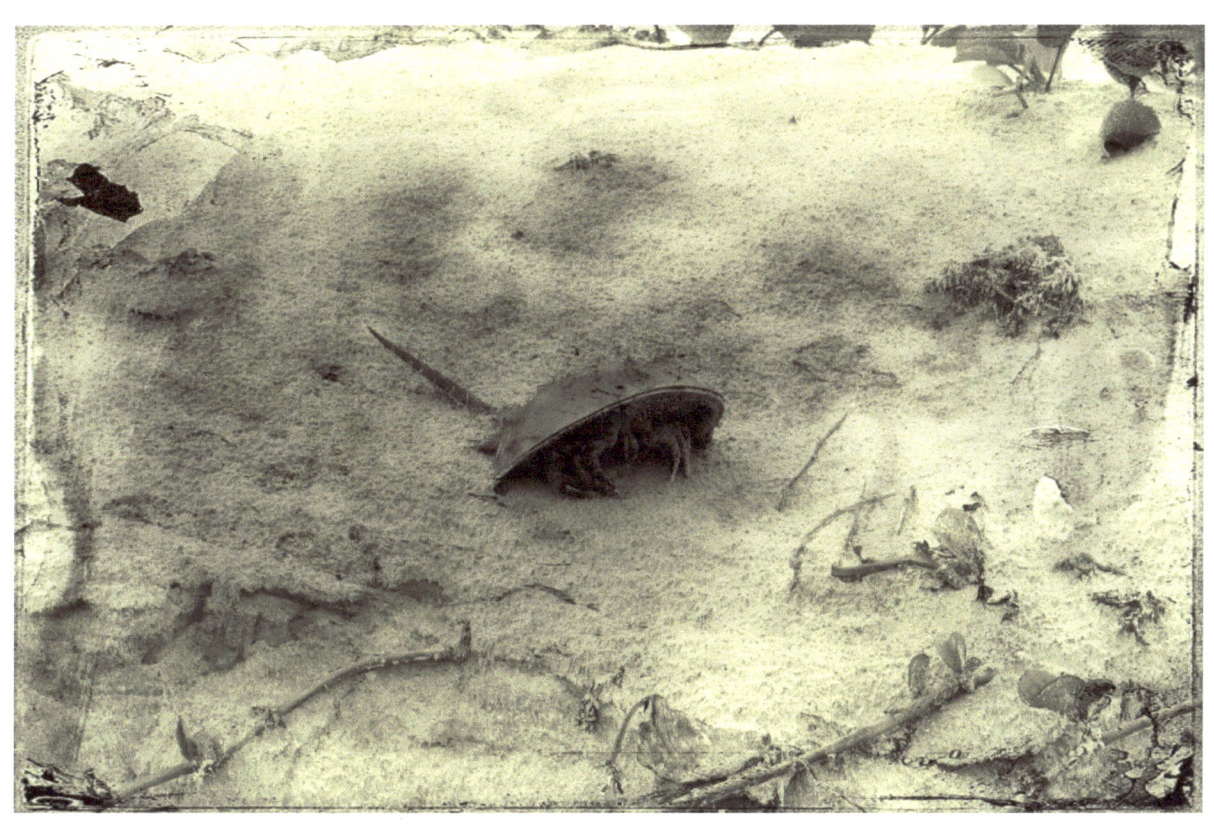

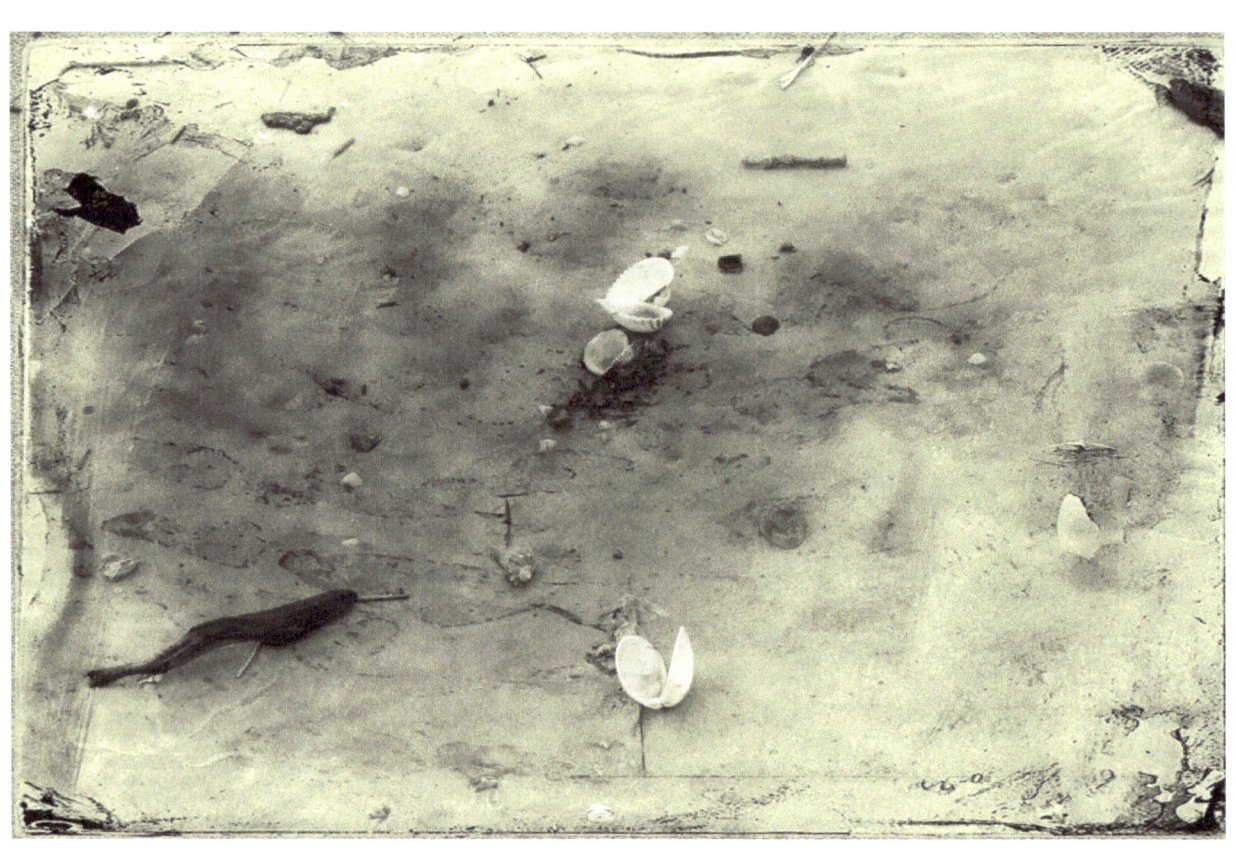

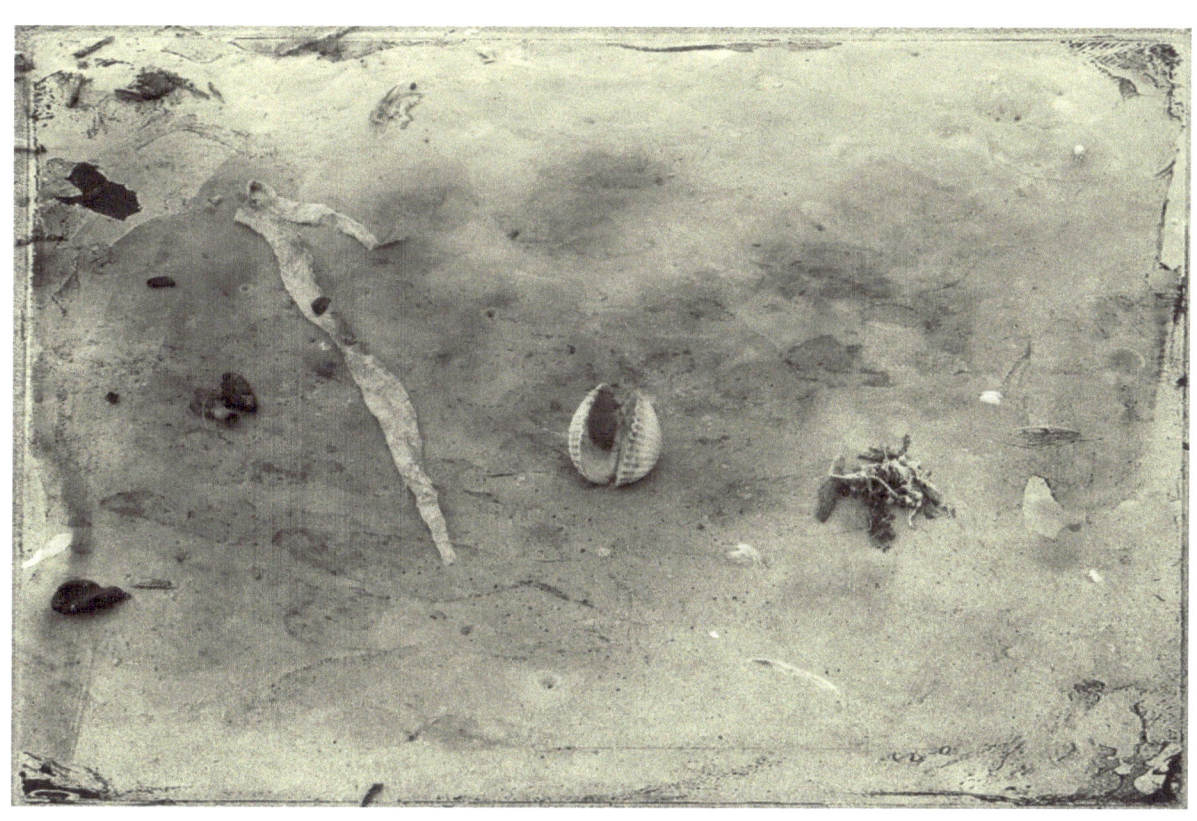

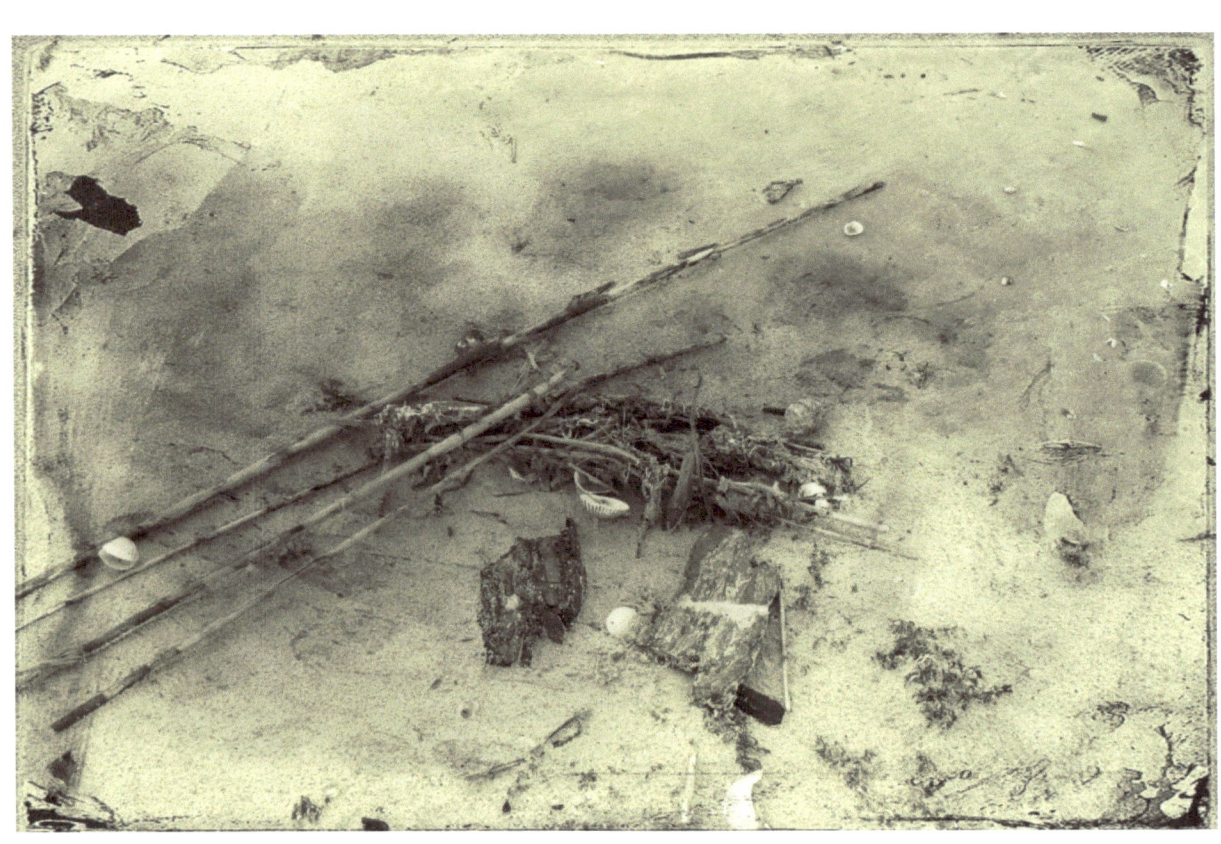

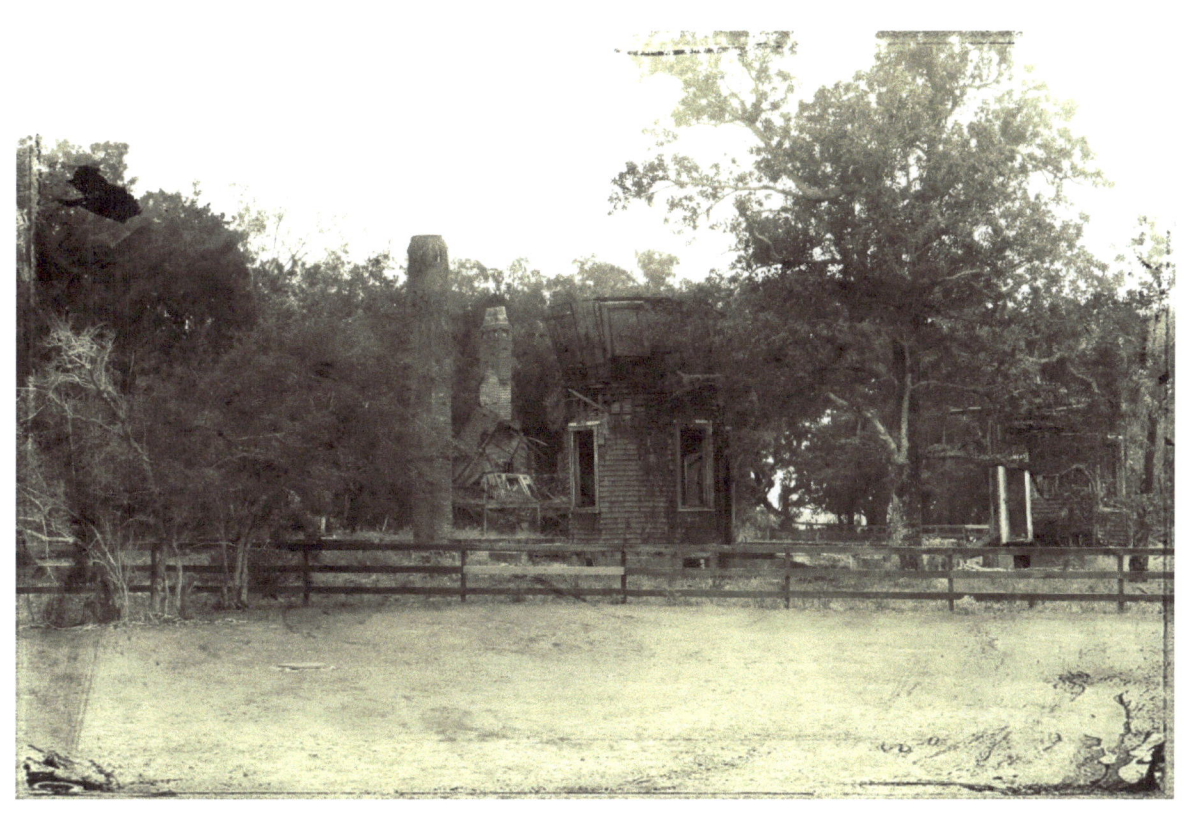

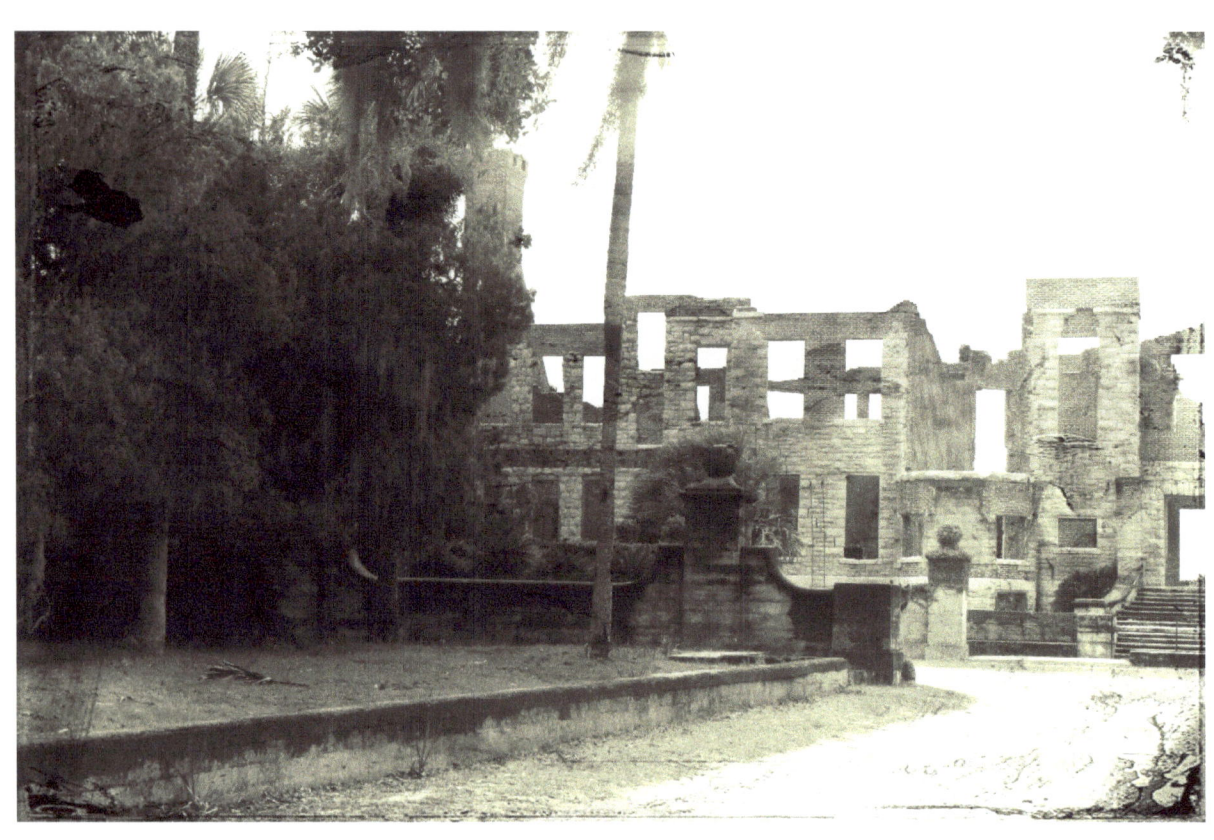

ABOUT THE AUTHOR

Francesco Salomoni is an international photographer and artist.
Born in Rome, Italy, he lives and works in Florida.
www.francescosalomoni.com

www.ingramcontent.com/pod-product-compliance
Lightning Source LLC
Chambersburg PA
CBHW050803180526
45159CB00004B/1539